P9-BYN-005

HANDMADE NATION

handmade NATION

The RISE of DIY, Art, Craft, and Design

× × × × ×

FAYTHE LEVINE AND CORTNEY HEIMERL

this Book is Dedicated to the Indie Craft Community

Published by
Princeton Architectural Press
37 East Seventh Street
New York, New York 10003

For a free catalog of books, call 1.800.722.6657.
Visit our website at www.papress.com.

© 2008 Princeton Architectural Press
All rights reserved
Printed and bound in Hong Kong
11 10 09 4 3 First edition

No part of this book may be used or reproduced in any
manner without written permission from the publisher,
except in the context of reviews.

Every reasonable attempt has been made to identify
owners of copyright. Errors or omissions will be
corrected in subsequent editions.

Editor: Clare Jacobson
Designer: Deb Wood

Special thanks to: Nettie Aljian, Sara Bader,
Dorothy Ball, Nicola Bednarek, Janet Behning,
Becca Casbon, Carina Cha, Penny (Yuen Pik) Chu,
Russell Fernandez, Pete Fitzpatrick, Wendy Fuller,
Jan Haux, Aileen Kwun, Nancy Eklund Later,
Linda Lee, Aaron Lim, Laurie Manfra,
Katharine Myers, Lauren Nelson Packard,
Jennifer Thompson, Arnoud Verhaeghe, Paul Wagner,
and Joseph Weston of Princeton Architectural Press
—Kevin C. Lippert, publisher

Library of Congress Cataloging-in-Publication Data
Levine, Faythe, 1977–
 Handmade nation : the rise of DIY, art, craft, and
design / Faythe Levine and Cortney Heimerl.
 p. cm.
 ISBN 978-1-56898-787-3 (alk. paper)
 1. Handicraft—United States. 2. Artisans—United
States. 3. Handicraft industries—United States.
I. Heimerl, Cortney, 1981– II. Title.
 TT23.L487 2008
 745.5—dc22

 2008003289

Contents

NORTH EAST

South east

Midwest

SOUTH CENTRAL

West

Preface

This is it, my first book, my opportunity to tell you why creativity and the DIY ethos are so important to me, and why I think that both can empower you and change your life.

I encountered the indie craft scene in 2003 as a vendor at the first Renegade Craft Fair in Chicago. Until then, I had never set up a display table or sold my work to shoppers face to face. My table came together haphazardly, but it worked. I wasn't the only one with this experience; I could tell that other vendors were feeling as overwhelmed as I was. I remember some people laid out blankets and hawked their wares as if it were an impromptu yard sale. Others didn't even have change for the shoppers. A lot of us had no clue what we were doing, but there was this exhilarating energy throughout Wicker Park. Around me were my peers, people who were taking their lives into their own hands and creating what they didn't find in their everyday lives at school, home, and work. We all had a common drive to create, and this was the platform for us to come together and share our work with each other and the public. Many of the hundreds of shoppers who turned out that year talked about how exciting it was to see handmade stuff they could relate to and how good they felt about purchasing work directly from the artist. I knew that something big was happening.

The Renegade vendors displayed work that was a marriage of historical technique, punk, and DIY ethos. Our handmade goods were influenced by traditional handiwork, modern aesthetics, politics, feminism, and art. We were redefining what craft was and making it our own.

The fair stressed the importance of independent artist-made goods and having a platform to sell them. Without really being conscious of it, we were creating an independent economy free from corporate ties. I quickly realized I was a part of a burgeoning art community based on creativity, determination, and networking. I knew I had found my people. I left Chicago feeling so inspired, empowered, and motivated to

do more, to make more. Still, I had no idea how my life would begin to revolve around this unfolding movement.

The indie craft community is the most supportive group of people I have ever encountered. Makers share their resources, do collective advertising, promote one another's work on their websites, do trades, and share skills. New community members are always greeted with nurturing and encouraging words, advice on running a business, and tutorials on how to get started with a project.

Inspired by this massive support system, I was motivated to give back to the community. I wanted to make sure my city, Milwaukee, was included in this growing trend of support for emerging artists. After a year of running my crafty business Flying Fish Design, I founded the Art vs. Craft fair. Soon after, I opened Paper Boat Boutique & Gallery with Kim Kisiolek.

Just a few years after my first Renegade experience, the craft scene was growing and developing. It reached out virtually through websites, blogs, and online stores, while brick-and-mortar boutiques, studios, galleries, and craft fairs connected the greater public regionally. Worried that things would change too fast and all of the accomplishments of our community would never be accounted for, I felt driven to capture the heart of the movement, and I set out in 2006 to document the indie craft community.

Fifteen cities and 19,000 miles later I was well on my way to having a documentary film about the new wave of craft in America. During production I had the pleasure of interviewing over eighty individuals, 95 percent of whom are women, who make up a community that shares the desire to produce change through the passion to create. I have documented a community of artists, crafters, makers, organizers, critics, curators, cultural theorists, and historians who work together to nurture entrepreneurialism, preserve feminine heritage, and wield great economic power. This footage is now compiled into a feature-length documentary called *Handmade Nation: The Rise of DIY, Art, Craft, and Design*, to be released in 2009.

This book, based on footage and interviews from the documentary, is the first of its kind intended to celebrate the maker and the craft community. There are many different faces and lifestyles behind our movement, and I feel compelled to share with you all of the amazing creatively diverse people I have met along my journey. By featuring makers from across the United States, I show that there is an abundance of talent in all corners of our country. The contributing essayists give detailed accounts of the history and current theories, ethics, and goals of the indie craft community. The featured makers and essayists are only a small fraction of those who make our community tick, but they show that DIY is not only a term we use, but a lifestyle we live.

We are celebrating a generation of makers. We are reshaping how people consume and interpret the handmade. I want to remind people that craft is what you make it. *Handmade Nation* attempts to capture what is happening in this amazing community, of which I consider myself a part. It is a labor of love, appreciation, and respect.

Our community is just beginning to grow into our roles of knitter, book binder, shoemaker, painter, seamstress, potter, etc. We appreciate the generations of makers who came before us and from whom we draw inspiration and support. In turn, we are setting the groundwork for future generations, leading by example and showing the creative paths you can take.

For me, sewing, playing music, making art and films, and even writing this book are about having control over my life. I am making my own destiny with what I create, whether it is with the materials I pick, the colors I choose, or the words I write. My aspiration is that the appreciation of the handmade will continue to grow in generations to come. I hope this book educates, inspires, and provides guidance for others to join the handmade nation.

Warmly,

Faythe Levine

Acknowledgments

Thank you to the featured makers and contributing essayists who worked with us on such an ambitious deadline.

Thank you to Kate Bingaman-Burt, who worked diligently by our side throughout the manuscript-writing process. We are lucky to have her eye for design and love of typography as a part of this book.

Thank you to Andrew Wagner, senior editor of *American Craft* magazine, for his support and eloquent introduction.

Thank you to our editor, Clare Jacobson, and everyone at Princeton Architectural Press for believing that the new wave of craft is deserving of such grand recognition.

We would like to thank our parents, Suzanne Wechsler, Richard Merlin Levine, and Richard and Cheryl Heimerl, for always supporting us creatively.

Faythe would like to thank the crew of *Handmade Nation* the documentary: Micaela O'Herlihy, director of photography; Cris Siqueira, editor; Joe Wong, assistant editor; and Drew Rosas for additional camera and sound work. Additionally, Faythe would like to thank Wooden Robot, who provided music for the documentary soundtrack and Kim Kisiolek, her business partner at Paper Boat Boutique & Gallery.

Faythe would especially like to thank her top dog, Nathan Lilley.

THE NEW WAVE OF CRAFT
when it all began

WWW.BUYOLYMPIA.COM
goes LIVE

THE GLITTER BOARDS,
An alternative crafting community
goes LIVE

JEAN RAILLA puts out
CRAFTY LADY

WWW.GETCRAFTY.COM
goes LIVE

1994 1996 1997 1998 1999

Amy Schroeder puts out

VENUS ZINE

Young Blood Gallery
opens in Atlanta, GA

La Superette is HELD in PARIS
(it is later moved to NYC)

BUST MAGAZINE
Runs a hipster crafting
column called:
 "SHE'S CRAFTY" DEBBIE Stoller STARTS A
 "STITCH 'N BITCH"
 GROUP in NYC

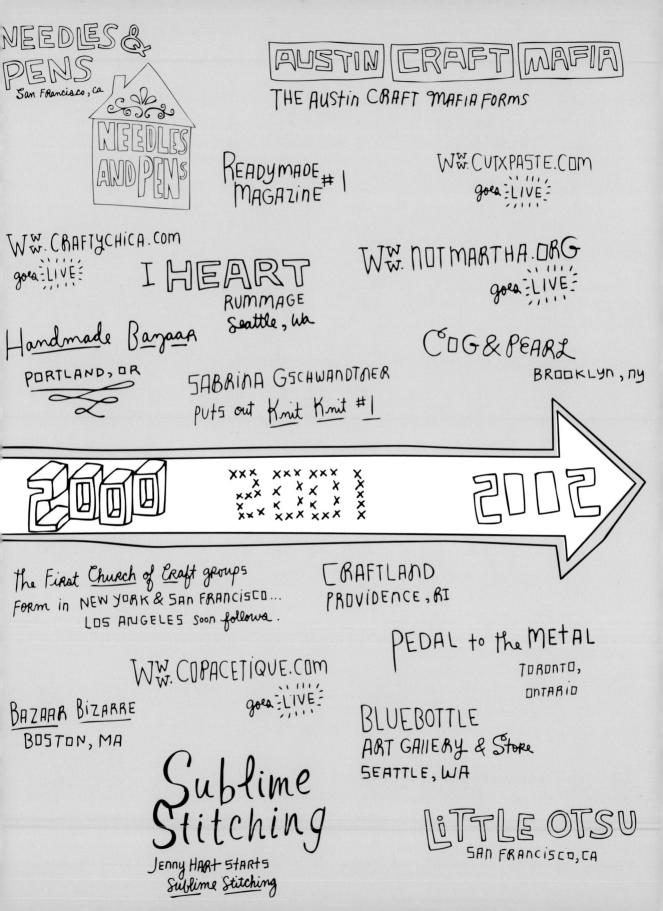

WWW.microrevolt.com goes LIVE

PDX SUPERCRAFTY
portland, OR

CHURCH of CRAFT
forms in Austin, TX

KRAFTWORK
Atlanta, ga

DEPART·ment
CHICAGO, IL

Crafty Planet
minneapolis, mn

Stitch Austin

WWW.DIYBRIDE.com goes LIVE

Handmade ARCADE,
PITTSBURGH, PA

the RENEGADE CRAFT FAIR!
Chicago, IL

poketo
LAUNCHES THEIR FIRST ARTIST WALLETS

Art VS. CRAFT
Milwaukee, WI

Crafty Bastards
Washington DC

WWW.HomeOFtheSAMPLER.com goes LIVE

2003 2004

DIY TRUNK SHOW
CHICAGO, IL

Fasten CLOTHING CO-OP forms in Milwaukee, Wi

WWW.CRAFTSTER.ORG goes LIVE

BLISSFUL REVOLUTION ARTS & CRAFTS BAZAAR
PORTLAND, ME

Church of Craft forms in POATLAND, OR

THE LADIES INDEPENDENT DESIGN LEAGUE forms in NYC

CRAFT NIGHT
MEETINGS BEGIN in LA

SHOP n' MOSH
Baltimore, MD

CRAft Mafias FORM in Chicago, IL & Houston, TX

Magpie
Somerville, MA

WWw.mymy.US
goes LIVE

Beaux Arts Bizarre
COLUMBIA, MO

GETCRAFTY: Hip Home Ec
by Jean Railla

BUST
MAGAZINE HOLIDAY
CRAFTACULAR
Brooklyn, NY

Sodafine
BROOKLYN, NY

WWw.Supernaturale.com
goes LIVE

URBAN CRAFT
UPRISING
Seattle, WA

Beehive Co-op
Atlanta, GA

art★star
ART STAR Gallery & Boutique
Philadelphia, PA

HANDMADE DETROIT

Renegade Craft Fair
Brooklyn, NY

MUTATION
CRAFT FAIR → SAVANNAH, GA

Stitch Lounge
San Francisco, CA

CRAFTin' OUTLAWS
Columbus, OH

CRAFT MAFIAS form in:
Louisville, KY / Richmond, VA / Vancouver, BC /
Burlington, VT / Miami, FL / New Orleans, LA /
Pittsburgh, PA

XXX XX XX XXX XXX
XXXX XX XX XX
XXX XX XX XX
XXX XXX XXX XXX

WWw.REDEFiningCRAFT.com
goes LIVE

HIGHNOON
CRAFTACULAR
MADISON, WI

Crafters Local 612
forms in: Minneapolis, MN

Cinders
BROOKLYN, NY

SPARE PARTS GALLERY
Columbia, MO

INDIE CRAFT
Experience: Atlanta, GA

FIRST Episode of
CRAFTYPOD

PARTS and LABOUR
AUSTIN, TX

Stitch-IT-Kit
BY Jenny Hart

WWw.craftRevolution.com
goes LIVE

NO COAST CRAFT-O-RAMA
Minneapolis, MN

THE Girlie SHOW
Oklahoma City, OK

WWw.theswitchboards.com
goes LIVE

URBAN STREET
BAZAAR
Dallas, TX

Etsy

CRAFT CORNER DEATHMATCH IS ON TV

WWW. ETSY. com

goes LIVE

fred flare

launches its NEXT BIG THING contest

PUNK ROCK

The Good Catch Craft Fair
TORONTO, ON

CRAFT FAIR
San Diego, CA

Wholly Craft!
Columbus, OH

SUPERCRAFTY:
OVER 75 Amazing HOW-TO Projects
BY PDX SUPERCRAFTY: Susan Beal,
Torie Nguyen, Rachel O'Rourke, Cathy Pitters

Swap-O-Rama-Rama
holds its first event
in NYC

CRAFT MAFIAS

form in St. Paul, MN / Anchorage, AK /
Tulsa, OK / Omaha, Ne / Leeds, UK /
Dallas, TX / San Antonio, TX /
Knoxville, TN / New York City, NY /
Washington DC / Charlotte, NC /

WWW. Save Gocco. com

goes LIVE

52 PROJECTS
Random Acts of Everyday
Creativity By:
Jeffrey Yamaguchi

セーブ
ゴッコ
Save
gocco

Spring Bada-Bing
Craft SHOW → RICHMOND, VA

DETROIT URBAN
CRAFT FAIR
Detroit, MI

CHURCH of CRAFT
in Athens, GA

2006

WWW. ExtremaCraft. com

goes LIVE

CRAft Sanity PODCAST

WWW. WESTCOASTCRAFTY. com

goes LIVE

PAPER BOAT
BOUTIQUE & Gallery
Milwaukee, WI

MAKER FAIRE
Bay Area

make SHOP & STUDIO
DALLAS, TX

FELT CLUB

PRETTY CRAFTY THINGS
Leeds, UK

The Glitter Workshop
MADISON, WI

Knitta

BOMBS
Houston, TX

Pandora's Trunk
San Francisco, CA

CROQZiNe. COM

CROQZINE issue #1 Released

FELT CLUB
Los Angeles, CA

HANDCRAFT IN A HECTIC WORLD

Strange Folk Festival
O'FALLON, IL

WWW. Whipup. net

goes LIVE

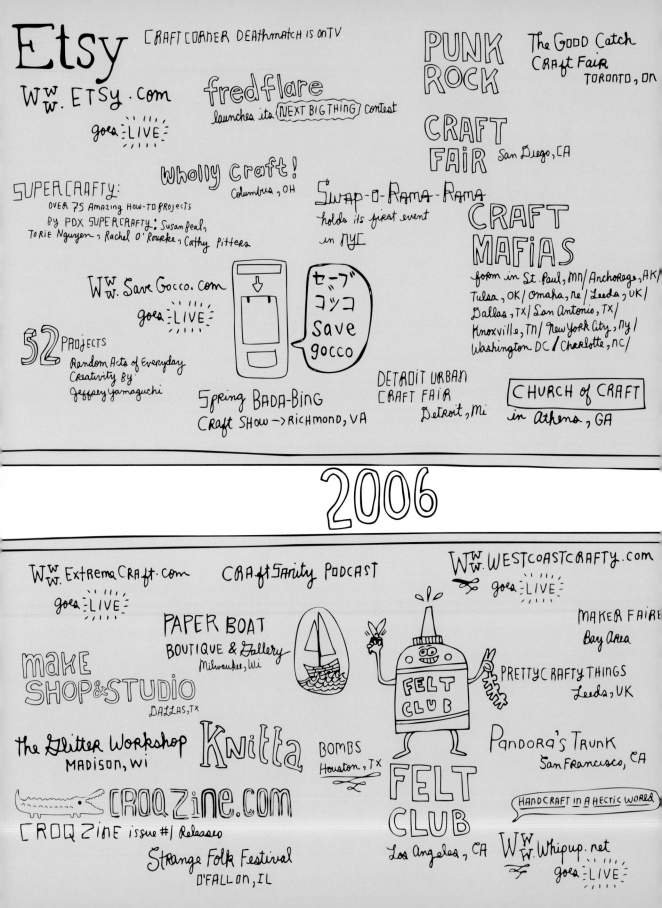

Fancy Tiger
DENVER, CO

Church of Craft
forms in Kansas City, KS
& Kansas City, MO

Indie Emporium / Tulsa, OK

Maker Faire / Austin, TX

Pile of Craft / Baltimore, MD

Yarn Con / Chicago, IL

Craft: volume 01
magazine

I Made It Market / Pittsburgh, PA

Stylelicious TV Series
HOSTED By members of the
AUSTIN CRAFT MAFIA

my my
HatBoro, PA

Has its first attempt @ a functional definition for DIY craft

Craft Lab TV Series
Hosted By Jennifer Perkins

WWW. RedefiningCraft.com

TEASE: 50 Inspired T-shirt Transformations By SUPERSTARS of Art, Craft & Design
ED. Sarah Sockit

City of CRAFT
Toronto, ON

Craft Republic
POMONA, CA

THE First CRAFT Congress
Held in Pittsburgh, PA

REFORM School
Los Angeles, CA

the AMERICAN CRAFT CONFERENCE has the theme: SHAPING THE FUTURE OF CRAFT

HANDMADE PARADE
Sacramento, CA

The American CRAFT Council show opens its doors to young emerging designers

Holiday Heap / BALTIMORE, MD

2007

Renegade Handmade
CHICAGO, IL

ADORN MAGAZINE

Craftivity By Tsia Carson

ROB WALKER writes: CRAFT WORK for the NEW YORK TIMES MAGAZINE

The Senior Editor of CRAFT magazine, Natalie Zee Drieu, appears on the CBS morning show

PRODUCTION BEGINS for HANDMADE Nation (aka indie CRAFT DOCUMENTARY)

Etsy launches

The Storque
An online magazine

indie CRAFT DOCUMENTARY

Knitta
BOMBS China

CRAFT MAFIAS
form in Baltimore, MD /
Phoenix, AZ / Colorado Springs, CO /
Atlanta, GA / Sacramento, CA /
Lubbock, TX / Glasgow, UK /
Cincinnati, OH / Norfolk, VA /
Manchester, UK / Hollywood, FL /
Petaluma, CA / San Diego, CA /
North Park, CA / Long Beach, CA /
Las Vegas, NV

Crafty Cotillion FORMS in COLUMBUS, OH

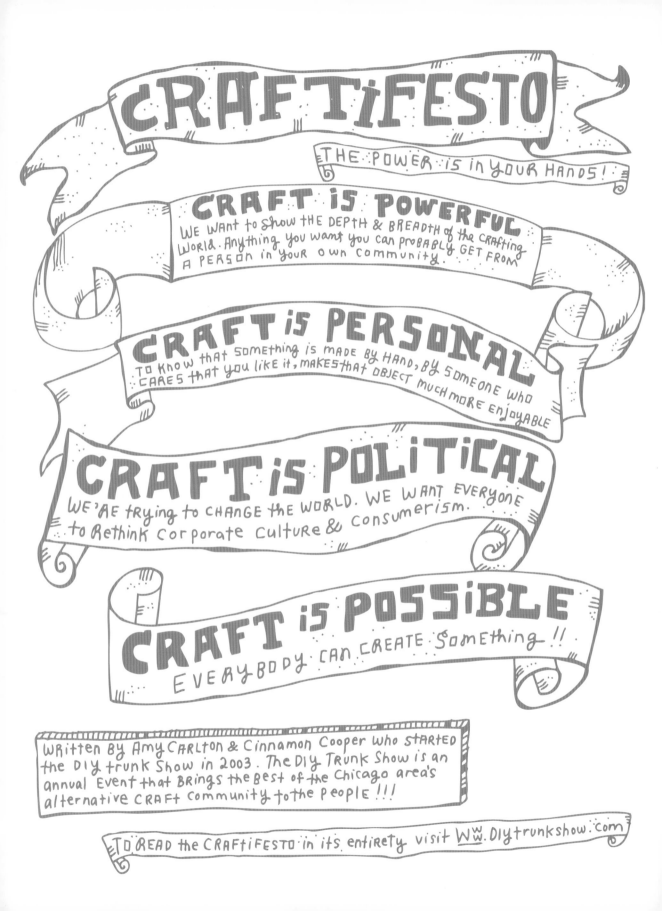

CRAFTIFESTO

THE POWER IS IN YOUR HANDS!

CRAFT IS POWERFUL

WE WANT to SHOW THE DEPTH & BREADTH of the CRAFTING WORLD. Anything you want, you can PROBABLY GET FROM A PERSON in your own community.

CRAFT is PERSONAL

TO KNOW that something is MADE BY HAND, BY SOMEONE who CARES that you like it, MAKES that OBJECT much MORE ENJOYABLE

CRAFT is POLITICAL

WE'RE trying to CHANGE the WORLD. WE WANT EVERYONE to RETHINK Corporate Culture & Consumerism.

CRAFT is POSSIBLE

EVERYBODY CAN CREATE something !!

WRITTEN BY Amy CARLTON & Cinnamon Cooper who STARTED the DIY TRUNK SHOW in 2003. The DIY TRUNK SHOW is an annual EVENT that BRINGS the BEST of the Chicago area's alternative CRAFT community to the PEOPLE !!!

TO READ the CRAFTIFESTO in its entirety visit WWW.DIYtrunkshow.com

Craft:
It's What You
Make of It

Andrew Wagner

The term "do it yourself" (or "DIY") as a point of differentiation within the world of craft has always struck me as odd. Aren't the words "craft" and "DIY" interchangeable? Aren't all makers, to some extent, doing it themselves? Like everything else in life, though, craft is not linear. And when confronted with the tangled webs that have been woven into the realm of craft, human instinct kicks in and initiates an innate drive for definition. But craft is a big, unwieldy beast of a phenomenon not so easily wrestled into its Sunday best. Encompassing not just a singular activity (in a very broad sense, the act of "making"), craft also often carries with it an ideology suggesting a particular outlook on the world. In other words, craft is not simply about making but about making a political statement—for better or worse—and has been since the days of John Ruskin, William Morris, and the Industrial Revolution. This, of course, is where things get tricky. Some people want to embrace craft for its essence of craftsmanship—that is, the quality of a piece of work, the time and effort that went into its production. Others are excited by craft because of its inherent otherness—that is, its unique ability to set its practitioners outside of mainstream industrial society. Making your own clothes, your own dinnerware, your own art has become a way to politely (or maybe not so politely) give "the

man" the middle finger, for lack of a better term. The question then becomes, can you have one craft world without the other?

Despite what some may say, it is on this slippery slope of mixed metaphors and ill-defined terms where things start to get exciting. I like to think of craft as a living, breathing thing—something so complex and at times convoluted that one would be a fool to try and pin it down. In this same way, I like to think of craft like I think of people—that is, creatures who are sometimes happy, sometimes sad; sometimes angry and violent, other times solemn and passive. A person is not complete if they are simply one way or the other. In much the same way, craft is not really complete if it is strictly confined by narrow definitions that fail to capture its vastness. Craft, removed from its political energy and ideologies, always seems to be missing something, while craft that exists merely as a way to make a statement seems equally at a loss. Therefore, one thing on which everyone seems to agree is that craft is complex and in need of a good psychiatrist. But those who manage to find a balance while steering clear of self-appointed mental-health workers purporting to have the craft cure-all are those who are able to create something unique—something that is truly craft, something that communicates. Craft is challenging but craft is also engaging. Craft is king and craft is queen. Craft is all encompassing and craft can be a circus. Without a doubt, it is all of this that makes craft difficult to understand and has caused fissures in the field. Some want it this way, some want it that way. But this uneasiness is precisely the thing that makes craft so good—it is what you make of it.

Admittedly, finding that balance on the precarious cliff called "craft" can be a struggle, as has been the case in recent history. Craft in the 1960s and '70s swung too far in one direction, as the hippy counterculture embraced it for its political, back-to-the-earth qualities while, for the most part, tossed actual quality aside. In reaction to this, makers of all sorts looked to distance themselves from this fervent

politicizing and embrace more attributes of the art world, namely its aesthetic values. As the '80s turned to the '90s, galleries and museums began to dominate the high-end craft world, and discussions with street-level craft movements had all but ceased. Fortunately, with the dawn of the new millennium, we've reached a moment of possibility, a chance at reconciliation perhaps. Maybe due to all the new (and old) information suddenly at our fingertips, the two worlds that were once connected at the hip have a chance to again draw from one another and elevate craft to its proper place in this world—as a uniquely qualified leader and a grounded member of a society that often seems on the verge of chaos. Sounds like a good plan to me.

NORTH EAST

TRACY BULL

HAPPY OWL GLASSWORKS CONCORD, MASSACHUSETTS WWW.HAPPYOWLGLASS.COM

I went to school for graphic design. After a few years of working in the field, I decided that I had enough of the stagnancy that comes with sitting at a computer all day. I needed a change of pace. I applied to school to study glass arts. I explored different areas of glassmaking, and I thought I'd go into glassblowing. It was a very "macho" area of the field, and I thought I had something to prove, being female. However, once I experimented with fusing glass, I realized I'd met my match. I continued exploring with different techniques, and suddenly found its similarity with graphic design—the flatness, the ability to take time to develop your design. It didn't have the time constraint that glassblowing had.

I graduated with a degree in what felt like "not much." I was frustrated and didn't know what my next step was. I moved to San Francisco to live with a group of friends, and I regressed to my gig of graphic design to pay the bills and to live the expensive Bay Area life. Then one day I saw an ad on Craigslist.org for a used kiln. It was small, but I had a garage where I could set it up. I began playing and it was fun.

At that point I moved to Montana for a change of pace. I got involved in a small co-op gallery there, where I eventually had a solo show and sold some small, functional pieces. It wasn't until I moved to Los Angeles that I really started taking the glasswork seriously.

I decided it was time to try to sell my work online.

Today, I'm motivated by the constant itch to evolve my art. Since I work with both glass and illustration, I usually have a lot going on in my head. This struggle between the two is usually won by illustration.

I am always looking to animals to inspire me and so I am motivated to learn more about them. In my work for Happy Owl Glassworks, I try to display their quirky characteristics. The naked mole rat, the bat, and the elephant shrews of the world just don't get enough affection.

Interviewed at her studio in Concord, Massachusetts.

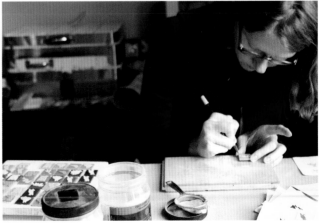

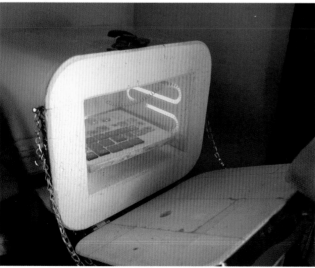

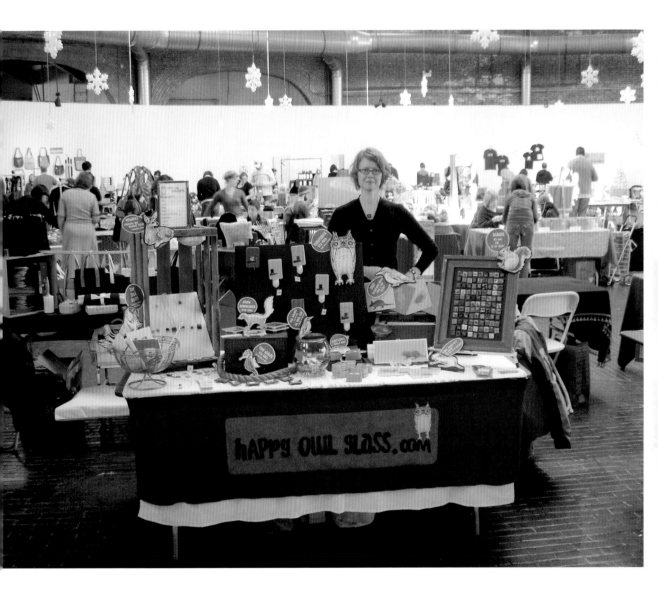

DEB DORMODY

IF'N BOOKS & MARKS PAWTUCKET, RHODE ISLAND WWW.IFNBOOKS.COM

When I began my business, If'n Books & Marks, I started out wholesaling. Doing traditional craft shows was just kind of a bonus side thing to get retail prices, which was exciting. I could sell okay at stores, but at those craft shows customers had pretty specific expectations of what they would find. My things were a little bit quirky and not as safe a bet for a present. Selling at fairs seems to be all about context. My books wouldn't sell that well next to batik silk scarves, but if that scarf had a skull on it, I'd do much better. Within the burgeoning indie craft community, my customers finally caught up to me.

I think that in this day and age, people are seeking out something that is authentic and personal. Buying from an indie crafter is a great way for someone to purchase something and feel good about it. There is the opportunity for a customer to meet the person who has made the item that they are purchasing. When buying from big-box retail stores, you can guess what person has made it in a foreign country and what that work was like, but you probably don't want to think about it. When you purchase indie craft over the internet or at a craft show, it is a much more personal interaction. With the economy the way it is and the unstable job market, it makes sense for crafters to want to start out on their own and create items for people to purchase. In terms of the movement's longevity, I think that it will certainly have staying power with customers who are concerned about global economy issues and keeping the local economy strong.

Interviewed at her studio at Pawtucket, Rhode Island.

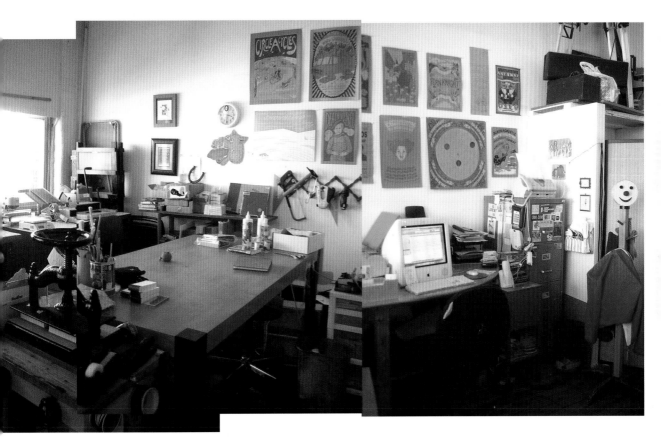

HEIDI KENNEY

MY PAPER CRANE WAYNESBORO, PENNSYLVANIA WWW.MYPAPERCRANE.COM

My mom has always sewn. When I was growing up she worked for Annalee, which is a doll company, and also for a company called Mutts & Mittens making dog toys. My sisters and I would get paid five cents for every dog toy that we turned right side out and stuffed. Sewing was always something we did. I started making my own stuff when I was very young, as far back as I can remember. I think the first things I made were paper dolls, and doll clothing that was cut out and tied rather than sewn.

For my business, My Paper Crane, I sew a lot of plush things. I also do paintings and spin yarn, but mostly it's plush. I didn't have any formal training in art or anything, but I have always sewn and I have always made stuff.

About three years ago, I started out making weird purses, but I was more into the weirdness of them than the construction of purses. When I turned to plush I didn't have to worry about making straps for purses or making them functional. Then it kind of went from there.

When I first started my website, I had just had my youngest son. I thought I was just going to set up the site for fun so I could have a place to post what I made. I wasn't selling a lot then. I sold on consignment through one local store. I decided that a website would be kind of fun, and then people started to buy things. So I started selling and it got bigger from there. I began noticing other websites that were starting up and selling things. It was just kind of like a happy accident. My Paper Crane was for fun, and it turned into a big business.

Interviewed while vending at Renegade Craft Fair, Chicago, Illinois.

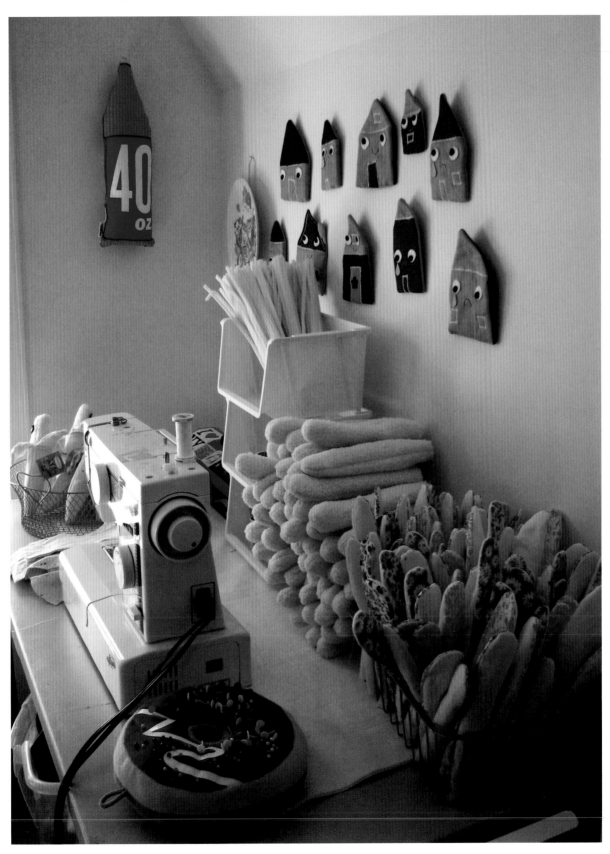

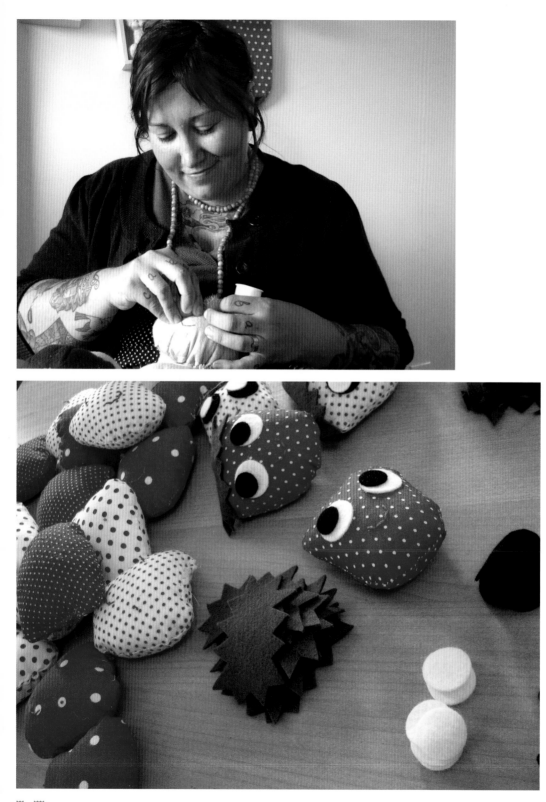

JENINE BRESSNER FIREWORKS! PROVIDENCE, RHODE ISLAND WWW.JENINE.NET

I like thinking about how making lampwork beads has been done before, but I am doing it anew, in my way and for myself, because I want to see new things. You can find examples of these beads that are two or three thousand years old in museums. It's funny that lampwork is historical and, in a way, it's traditional, but I make what I do because I want to see things that I have never seen before. I think of weird stuff or curious things and experiment and play around and create forms and then try to make them wearable.

One of the advantages of making things that I can wear is that I don't have to rely on a gallery. The world becomes the exhibition space. I can just wear things out into the world and it becomes accessible to anybody. A gallery is pretty intimidating to a lot of people. It seems so elitist. Really, putting something on a pedestal to me says, "You can never do this." In that way, it also speaks down to people rather than encouraging them. If people approach me and they are excited about what I make, I tell them that they can do it themselves and I can show them how if they want to learn or they can order a kit in the mail.

When I was little, my mom was always playing with beads, and it made me want to play with beads. She would take me to the wholesale jewelry places in New York City and I would wander around these dusty aisles. I was so fascinated by sequins and seed beads. We went to a bead show when I was fourteen and there was a woman selling Italian glass, but mass produced in China and Mexico and India. I told the woman that I was going to learn to make these things one day, and the lady laughed in my face. I had forgotten that story for years.

I just try to remind people that they can do anything and that everything is possible.

Interviewed in her studio in Providence, Rhode Island.

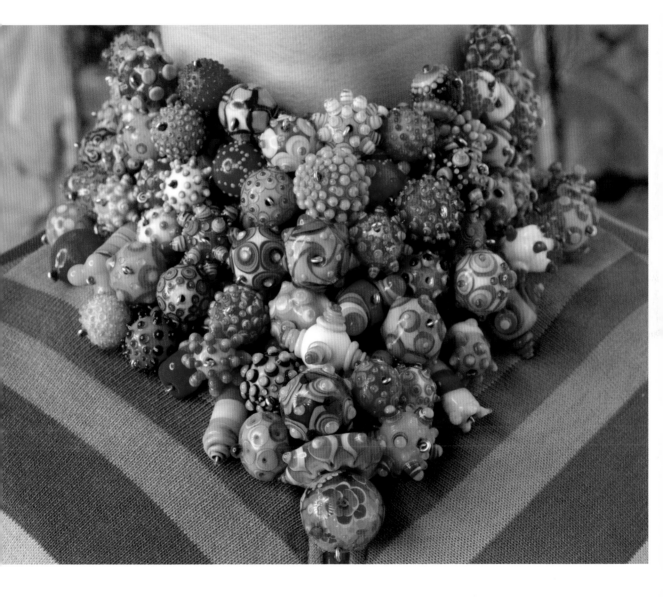

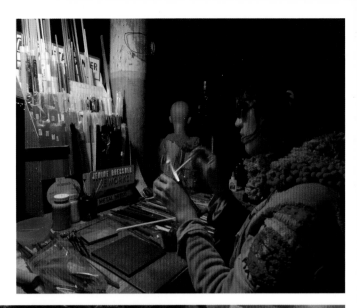

SABRINA GSCHWANDTNER

KNITKNIT NEW YORK, NEW YORK WWW.KNITKNIT.NET

I founded an arts journal called *KnitKnit* in 2002. I have published seven issues to date, which have been distributed throughout the United States and in France, Ireland, Japan, England, New Zealand, and Austria. I've curated exhibitions and events around themes and issues raised by the publication, and I also wrote a book called *KnitKnit: Profiles and Projects from Knitting's New Wave.* I write about art, artists, knitters, and designers for various magazines, and I make art in the form of installations, films, single-channel videos, and sculptures, which I show at galleries, museums, and other arts venues.

I am often asked, "Why is handcraft so popular?" I think that handcraft is popular right now as a reaction against a whole slew of things, including our hyper-fast culture, increasing reliance on digital technology, the proliferation of consumer culture, and even war. During all major wars in which America has been involved, handcraft has experienced a resurgence. I think that's definitely true right now. A lot of people have written about the return to homemaking and the interest in nesting after 9/11. I think that, in the United States anyway, our tentative international image and relationship to international communities has produced a lot of anxiety for people.

For some people, sustainability is a part of their handcraft practice. Other people want to see a project through from beginning to end, something they don't get to do in their daily lives. In their jobs, they do one part of producing something and they don't do the other parts. In producing a handcraft project, people can see something from start to finish and then have a material product that they can use themselves or give away. Even though we all have frequent access to the internet and are able to communicate with people through digital media, we are still sensual beings. We need to maintain a tactile relationship to the world.

I love making things. I love writing about aesthetic objects and their makers. I love conversations about making things. I love thinking about making things.

Interviewed at her studio in New York, New York.

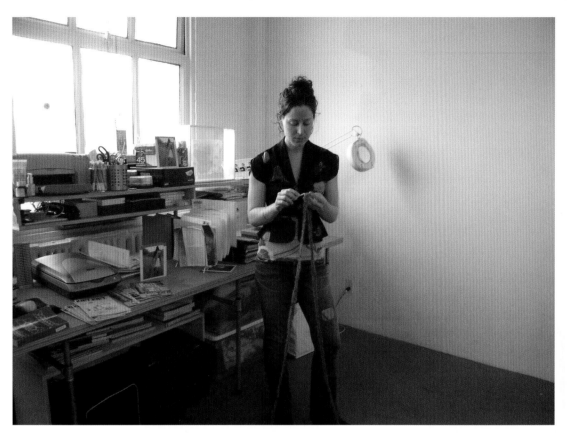

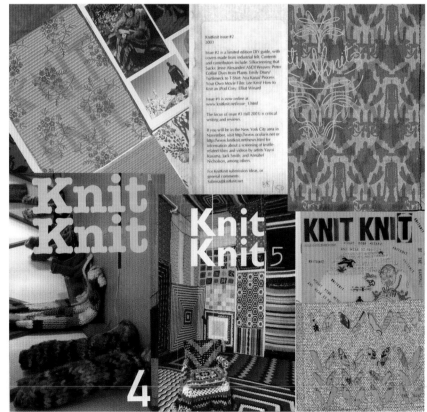

KnitKnit issue #2
2003

Issue #2 is a limited edition DIY guide, with covers made from industrial felt. Contents and contributors include: Silkscreening that Sucks: Jesse Alexander/ ASCII Weaves: Peter Collin/ Dyes from Plants: Emily Drury/ Turtleneck to T-Shirt: Aya Kanai/ Process Your Own Movie Film: Lee Knit/ How to Knit an iPod Cosy: Elliot Winard

Issue #1 is now online at www.knitknit.net/issue_1.html

The focus of issue #3 (fall 2003) is critical writing and reviews.

If you will be in the New York City area in November, visit http://www.ocularis.net or http://www.knitknit.net/news.html for information about a screening of textile-related films and videos by artists Yayoi Kusama, Jack Smith, and Annabel Nicholson, among others.

For KnitKnit submission ideas, or general comments: Sabrina@KnitKnit.net

86/450

Down the Tubes: In Search of Internet Craft

Garth Johnson

During a 2006 speech on net neutrality, Senator Ted Stevens (R-Alaska) famously described the internet as a "series of tubes." For the indie craft movement, the tubes are more like umbilical cords. Would there be indie craft without the internet? It may sound strange that a bunch of people who are trying to reclaim handicraft are using technology to do so, but it's undeniably true.

The modern craft fair evolved from church bazaars and hippie markets. In the 1990s, craft fairs grew in size and importance. Major shows like the American Craft Council connected crafters with a more affluent audience. As a result, crafters discovered the strategy of deliberately flattening out their work so that it looked better on slides. Craft fairs devolved into a tenth circle of Dante's Inferno, either catering to air-kissing ladies with turquoise jewelry and coiffured lap dogs, or stretch-pants- and gem-sweater-clad ladies snapping up purple pottery jars with "beanie money" stamped into them.

With the ascendancy of Etsy.com and other e-commerce sites aimed at the new wave of crafters, it's not far-fetched that today's artists tailor their work to look good on an LCD screen. Instead of homogeneity, the internet has fostered diversity through friendly

competition, resulting in a gloriously messy tangle of blogs, forums, projects, email groups, and social networking sites. When I sat down to puzzle out the best way to measure the vitality of the handmade nation, I couldn't think of a better yardstick than the internet.

I had a "traditional" art school education consisting of an undergrad art degree followed by a master of fine arts in ceramics. I always enjoyed using "hobby" glazes and commercial decals that were declared off-limits by professors. I always felt like I was the only one chipping away at mountain of drab orthodoxy. As it turns out, there was an army of people out there who found ways to rebel through their respective craft, and we all came together thanks to the magic of the internet. Before the internet came along, I was an isolated ceramic geek who grew up on a farm in Nebraska. Now, I'm a well-connected ceramic geek in Southern California with a network of enablers who push me to color outside of the lines.

What could be easier than taking a stroll through the "tubes" to take a snapshot of the crafty corner of the internet for posterity? I spend a lot of time trawling the web for weird and wonderful craft for my own website, Extremecraft.com, so I started listing my favorite web destinations. In the back of my mind, I knew what a huge undertaking sorting through the mountain of websites would be, but fortunately, I'm delusional enough not to let that get in the way. My daily internet trips read like the *Family Circus* cartoons where Jeffy leaves a tangled trail of footprints through his neighborhood. I stocked up on caffeinated beverages, fired up my computer, and settled in for the ride.

I started by pointing my browser to Etsy, which is the craft website currently pulling in the most eyeballs. Etsy climbed to the top of the craft heap by providing an inexpensive way for artists to sell handmade work over the internet. Etsy also knows its audience— compulsive shoppers who banish their guilt by purchasing handicraft! I started by typing "bacon" into their search window. I was rewarded by sixty-five bacon products ranging from the obligatory (bacon scarves and bracelets) to the truly inventive (vegan bacon dog cupcakes).

Etsy has a stranglehold on the hearts of the indie craft world because it has literally thought of everything. In fact the only brewing dissent in their online forums has to do with users fearing that with so many search options, the interface is becoming too cluttered. In addition to Etsy's forums, which were abuzz with users trading tips and kvetching about stolen design ideas on the day that I visited, Etsy also lets users customize their experience.

An Etsy enthusiast can put together "treasuries" (sort of like Amazon.com lists); search by category, color, or geographic location; or view personal connections for any users on the site. There are also regular columns, reviews, events, guest articles, and even a "craftivism" section that helps users participate in charities and political projects. Like the photo sharing site Flickr.com, Etsy has perfected the art of obsession. When I checked their statistics on Alexa.com, I found out that the average user views about fourteen pages on the site per day. In contrast, MarthaStewart.com has a rate of about eight, and CNN.com has a rate of three and a half.

I followed a link on Etsy to Buyhandmade.org, a site sponsored by Etsy and other like-minded craft sites that let people pledge publicly that they will buy handmade gifts for their loved ones over the holidays. Pledge signers on the day that I visited were boasting about their crafting powers, ragging on Wal-Mart, and pimping their lines of botanical skin enhancers. I promptly signed the pledge and left a link to my blog.

I then followed a link on Buyhandmade to Craftster.org, the venerable craft networking site that lets users post their projects, share tips, and participate in the creation of an online "Craftopedia." A visit to Craftster is a great way to find out which way the wind is blowing in the craft world—which is to say, in a different direction from day to day. I clicked on one of the "hot projects"—a needle-felted hand puppet based on the Yip Yip aliens from *Sesame Street*. I hadn't thought about those characters for at least twenty years, but thanks to Craftster user

Krissykat, I know that they are indelibly burned into a corner of my brain (and that if the puppets were actually for sale, I would probably spend my allowance on one).

Crafters are natural organizers. Sites like Craftster, Etsy, Meetup.com and newcomer Ravelry.com let crafters find strength in numbers. A while back, I signed up for a mailing list for an annual Craft Congress, where people who organize craft fairs come together (in real life!) to trade war stories from the trenches of their respective events. Are crafters getting in touch with their thwarted inner sorority (or fraternity) member? I'm envisioning an alternate universe in which the Delta Delta Delta chapter spends all of its time knitting sweaters for penguins caught up in oil spills. I am in awe of the organizational skills of the craft fair organizers that I know, so a whole network of them might just take over the world.

It isn't all snuggles and pats on the back in the online craft world, though. Partaking in one of my favorite guilty pleasures, I click on my bookmark for Whatnottocrochet.wordpress.com. Since my last visit, the site was buzzing about a crocheted cow scarf with "fringe" made to look like udders. Readers were also dissecting some disconcerting knitted male thong underwear. The moderator asked, "If you meet a guy, and you get to the point in the night where you find out he's wearing a crocheted thong, are you going to die laughing or run away screaming?"

Still reeling from the crocheted thongs, I decided to drop in on some of my other favorite blogs. At Craftivism.com, Betsy Greer was offering up pictures of funnel cakes at the North Carolina State Fair. Natalie Zee Drieu at *Craft* magazine (www.craftzine.com) was blogging about Japanese plush breast toys, octopus scarves, and making your own candy bars. At Supernaturale.com, Scott Bodenner was enthusing about "crop art" and butter sculpture at the Minnesota State Fair. Whipup.net was showing off rings filled with Indian spices and trying to get readers to save Print Gocco. Julie Jackson (of

Subversivecrossstitch.com) was linking to free cross-stitch patterns based on the designs of British graffiti master Banksy.

After watching and rewatching Julie's video clip of Amy Sedaris and Martha Stewart comparing A-1 Steak Sauce to bong water, I was in need of some intellectual stimulation. Fortunately, I didn't have very far to go. There are plenty of big-brained folks out there who like to dissect the modern craft world, taking it apart to see what makes it tick. At Redefiningcraft.com, Dennis Stevens brought up the Guerilla Girls, *The Daily Show with Jon Stewart,* and *Handmade Nation,* the documentary, within the space of a single article about feminism. Over at Hobby Princess (ullamaaria.typepad.com), Ulla-Maaria is working on a way to use cell phones to interact with handmade objects.

Hobby Princess reminded me to check in on the geeky technological craft sites that I have bookmarked. For a lot of crafters who spent their childhood with their nose in a book or made crystal radios with their 130-in-1 Electronic Science Fair Project Lab, Diana Eng's emergence on *Project Runway* was a revelation. Her projects effortlessly combine technology, design, and fashion with a love of craft. Her blog (www.dianaeng.com) is always a treasure trove of her obsessions. I read her take on the chilling incident at Boston's airport where an MIT student wearing a hoodie adorned with LED lights was almost shot by overzealous security guards.

In search of more cheerful news, I headed over to *Make* magazine's website (www.makezine.com), which was in full-on Halloween mode. There's nothing like Halloween to bring the crackpot genius crafters out of the woodwork. In addition to a "realistic" werewolf costume, there were instructions for surviving the zombie apocalypse, a wrap-up of their biannual Maker Faire in Austin, and media of every type, including podcasts, PDFs, videos, and, of course, links to their old-fashioned print edition.

After a long day of "craft research" on the web, my browser window is overloaded with dozens of tabs that I left open so I can

write about them on my website later. The thought strikes me that the internet has turned me into the craft equivalent of a couch potato. Through the magic of the web, I can consume craft just like I would books, DVDs, or, gasp, television. Sites like Supernaturale and Whipup are like CNN, keeping me abreast of what's going on in the world. *Make* is sort of like ESPN, and, thankfully, Etsy is a guilt-free QVC. I can imagine my children in forty years plotting to cut off my internet access to keep me from getting scammed into buying bacon cufflinks and skull-and-crossbones iPod cozies.

For the time being, it's the internet that holds the craft world together. Show me a crafter without a website, and I'll show you a crafter who will probably have a website within six months. The handmade nation wields the internet just as effectively as it does a knitting needle or a roll of duct tape. I'm almost ashamed to admit that I'm a maker who hasn't actually *made* anything tangible in about six months. When I do, though, you'll be able to read all about it on the internet.

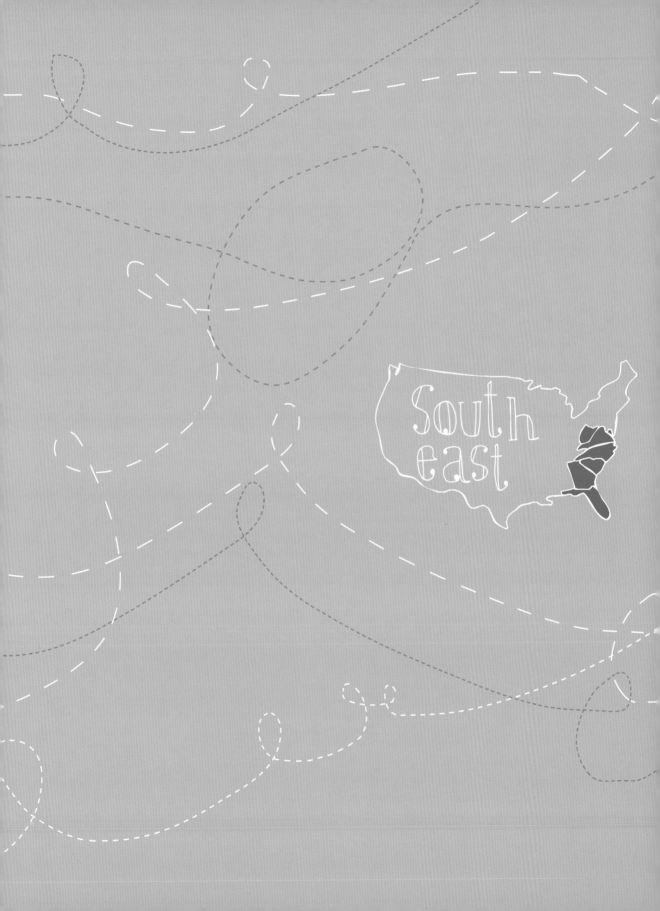

South east

Sarah Neuburger

THE SMALL OBJECT SAVANNAH, GEORGIA WWW.THESMALLOBJECT.COM

I make little clothespin people out of wooden clothespins with polymer clay heads. It actually started because I wanted to make something to give away free to people, and then my customers started to really like them. They got more and more elaborate. I also started making these rubber stamps, which people are really excited about.

To me, the biggest difference between people in this time and space is between people who just talk about good ideas and people who do it. It's those people who stop just talking about doing x, y, or z, but who actually get it done and work hard to make it happen and obsess over it, who succeed. I think it takes unique people to be optimistic enough to know from the get-go that it will happen, that they can do it themselves. It also takes an extremely organized person to keep it going once some momentum starts. It takes a very level and clear goal to keep it on track. We're artists, designers, business managers, accountants, customer-service representatives, publicists, writers, and website programmers. It takes a lot of internal motivation to keep it up!

The internet has made it possible for small-scale makers to get their wares seen by a much larger population than could have ever been imagined. And since I fully believe that for any object there is at least one person out there who is going to love it, this represents a strong advantage. The trick is finding that person, but with online shops. With Etsy.com and craft shows geared to young, quirky, and hip audiences, the likelihood that you're going to find that person is exponentially higher. So there are a lot more people making a little extra cash by making things to sell.

My work shows in galleries nationally and internationally, but my main focus is on my online shop, Thesmallobject.com, that sells the objects I make for our everyday—from artwork and housewares to stationery, paper goods, and rubber stamps.

Interviewed while vending at Renegade Craft Fair in Brooklyn, New York.

Zombie Tooth Whiskers Ghost Yeti Vampire Icecream

Acorn Rabbit Hedgehog Pigeon

"Brevity is the soul of wit"

quote Squirrel Xerox

A corn
B alloons
C lown
D ost bunny
E lephant
F lower
G host
H edgehog

I ce cream
J ump
K ite
L int
Matroyshka
N ut
U don
P igeon
Q vote

R abbit
S quirrel
T ooth
U ~~nder~~ nderdog
V ampire
W histers
X erox
Y eti
Z ombie

Flower

oysklia

Clown

underdog Dust Bunny

Odor

JVMP

Balloons

Nut

Kite

Elephant

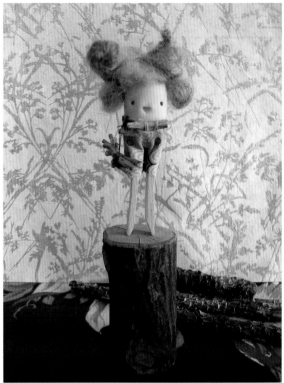

Shannon Mulkey

PATINA MARIETTA, GEORGIA WWW.ILOVEPATINA.COM

My earliest memories are of Shrinky Dinks, macramé, and bean collages. I loved to collect sequins and beads. I drew constantly. I started to spend more time painting in high school. I studied art in college—mostly drawing and painting with some photography thrown in. I studied under a metalsmith for a year and gave glass a try.

When I learned to sew in 2001, I never dreamed that my sewing would become my medium for my art. I knew that I wanted to learn to sew, but I didn't have any experience with a sewing machine. I was really intimidated by it. I could only sew if the machine was already threaded. A friend and I began experimenting. We took sweaters and cut them up and made really simple hearts and patches. At the time, the knitting sensation was just getting off the ground, but I didn't want to knit, to take new yarn and make something. There were so many awesome sweaters at the thrift store. It could be a really hideous sweater, but the yarn might be so nice. I had the urge to re-make it into something cool.

I have been growing my business, Patina, since 2002. It's my baby. It has changed so much from its inception. I really didn't know where it was going to go. I love showing at craft markets— going to Renegade, going to different cities and meeting people. I get to meet my audience at the indie craft shows. That's the most rewarding part. I love that. I love to see people try on a dress I made and have it be a perfect fit. And they tell me where they are going to wear the dress, which is amazing.

Interviewed in Atlanta, Georgia.

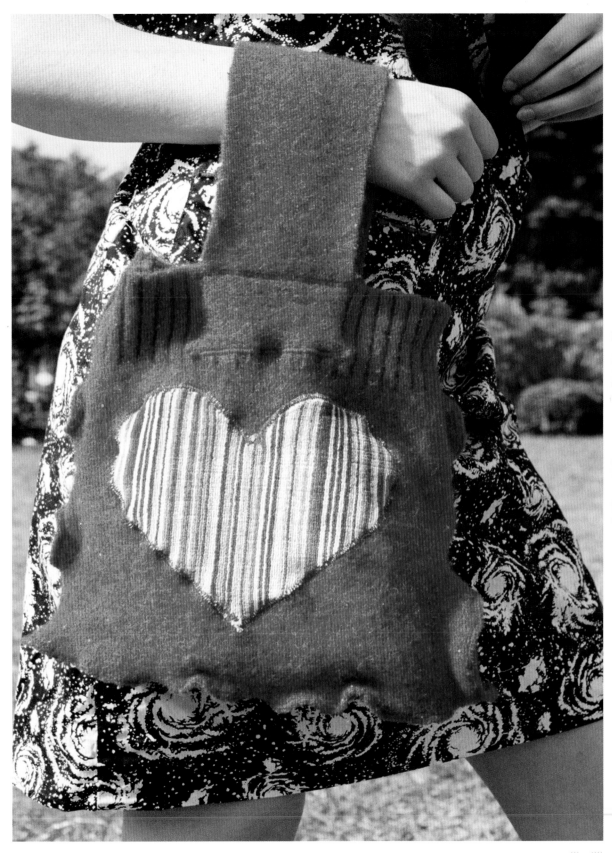

Christy Petterson

A BARDIS ATLANTA, GEORGIA WWW.ABARDIS.COM

I have been crafty my whole life. I always had a friendship bracelet in my pocket as a kid, and I was always working on different art projects. When I was younger I didn't differentiate between craft and art—it was just all creative. I almost minored in art in college, but it just didn't quite jive with me. I never really fit in with the art scene. I couldn't reach a level of success with art that I was happy with, and I wasn't as serious or analytical about art as the other artists around me. I never would have referred to myself as someone who did arts and crafts because that was looked down upon unless you did fine craft, and that was too serious for me. For years I felt like I was having a creative identity crisis. Was I an "artisan?" That sounded so traditional and old fashioned.

In the fall of 2003, I ran across two articles about Jenny Hart of Sublime Stitching. I was so struck by what she was doing that I looked up her website and started going through all her links. That was how I found Getcrafty.com and the forums on the site called Glitter. I realized that I found my people, and it took off from there.

Crafts keep me very busy. My own line is called a bardis. I make jewelry and hand-bound books and occasionally some clothes or other accessories. I incorporate screen printing as well as sewing whenever possible. While my own crafts were what first got me started, now they are sometimes more of a side project than my main focus. I co-organize an event called the Indie Craft Experience, a craft market held twice a year in Atlanta. I am also the coeditor of getcrafty, and I write a monthly column for the site.

Interviewed in Atlanta, Georgia.

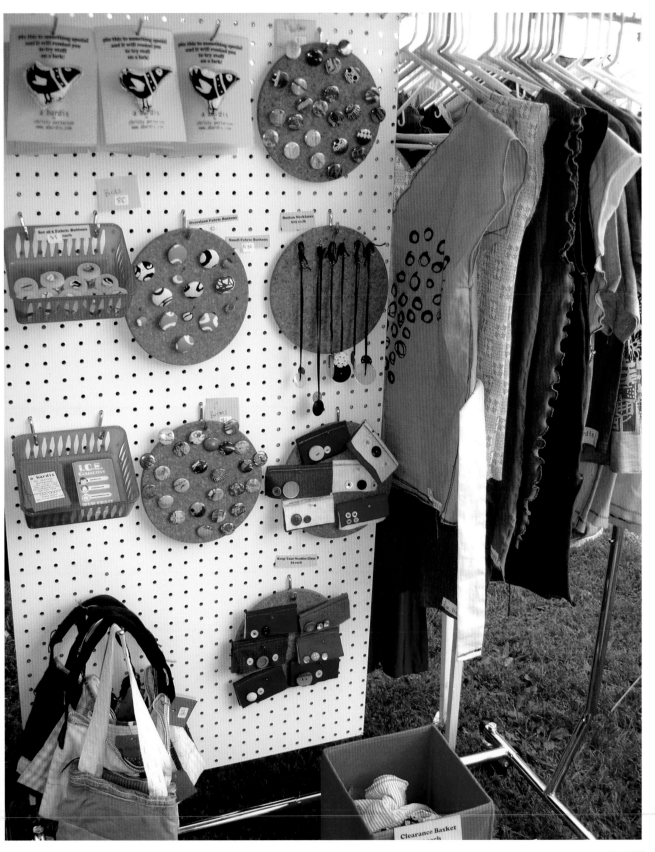

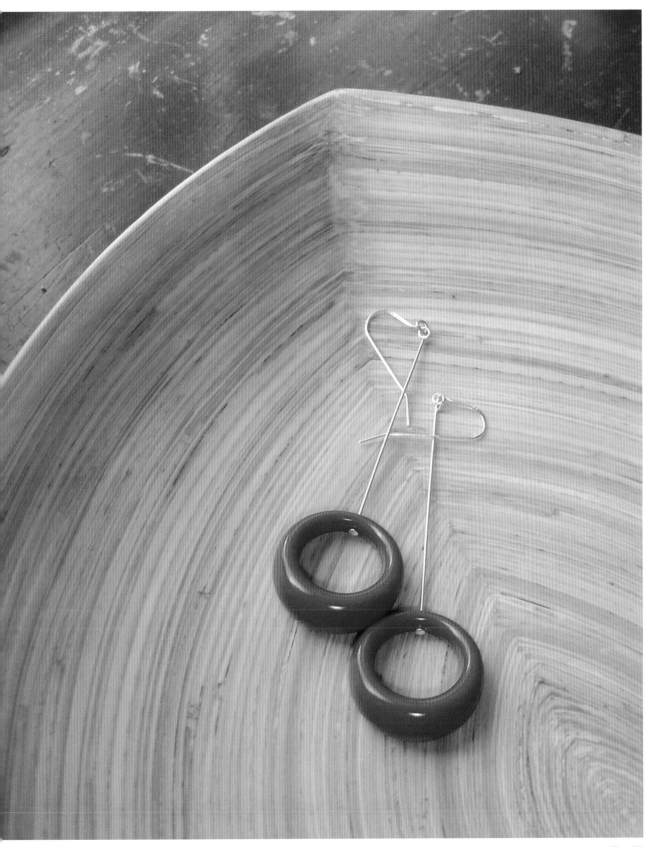

Alena Hennessy

ASHEVILLE, NORTH CAROLINA WWW.ALENAHENNESSY.COM

I lived in Portland, Oregon, for four years, and that is where I came across the craft scene. Portland is an amazing city and it's bubbling over with creative indie entrepreneurs. It was very inspiring. I did an art show for Seaplane, a design collective in Portland, and I was really blown away by what was happening there. At the time, I was a gallery artist, but I felt limited and almost a bit bored by just doing gallery artwork, so I started making clothes and tiles and prints. I saw websites of other online crafters and that's where I got my business idea. It just went from there. For me, it has been much more satisfying being a crafter than being a traditional artist.

In the craft community, I feel very connected to people whom I have never met in person, but have come to know through email alone. I feel like I am good friends with them, because we write back and forth and we have done trades, but I don't really know what they look like. I didn't expect to be so inspired by what everyone else was doing. There are so many amazing artists, crafters, and designers out there. Everyone is open to share information and help each other out and give each other tips. It is very different from a typical gallery art scene; it is a really wonderful sort of collaborative, supportive, noncompetitive network. I think it is pretty rare.

To be able to support oneself by creative means is something I do not take for granted. I continue to work hard on my business, and hopefully it will evolve.

Interviewed at Indie Craft Experience in Atlanta, Georgia.

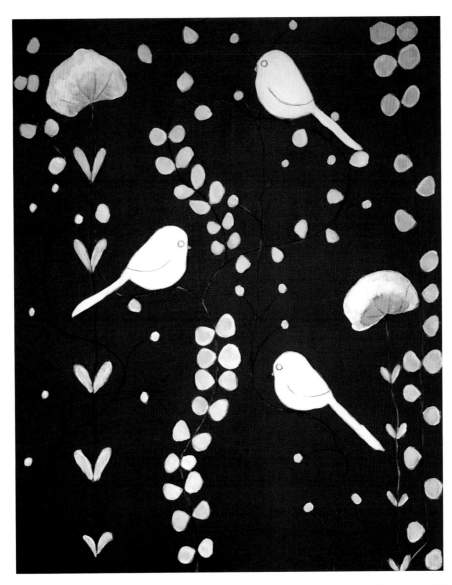

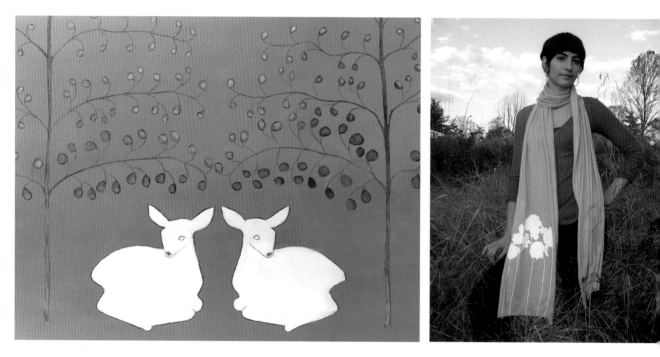

HANDMADE NATION

The Church of Craft: Making Our Own Religion

Callie Janoff

Like many of you, I've always been a maker, and I come by it naturally. When my mom wasn't making us rain ponchos or nutritious meals from *Diet for a Small Planet,* she was developing her own photos in the darkroom in the garage. It seemed natural that when she chose a "church" it was one that was just being made from scratch, and that she could help make it become a reality.

As a preteen I didn't have much interest in anything spiritual, but I did manage to learn to meditate at my mom's chosen house of worship, the Center for Spiritual Enlightenment. I even helped paint the bathroom of the new building. It was a DIY enterprise before the term was coined. These were people who saw an opportunity to craft their lives around what made sense to them, what inspired and motivated them, and took it! I didn't realize the profound impact this had on impressionable me until twenty years later, when it seemed natural enough to find myself officiating at a friend's wedding.

Before it actually happened, I was thinking about this wedding ceremony as an art piece. To me this seemed like the perfect way to fuse what was essentially a performance with something incredibly real. It turned out to be more like real life than any "art" I had ever made or participated in. It was thrilling! It was also majestic,

profound, and palpable. There were none of the qualities of abstraction I had learned to expect in art school. It was metaphysical, even spiritual. Now I was really confused.

What was that experience? I talked it over with some of the guests after that first wedding (I've since performed dozens). I had been unprepared for the cosmic love zap that actually occurred between these two friends while I was standing with them under their chuppah. Lying in the grass with the other crafty guests we asked each other, "What in your life is spiritual?" and, "If I'm a spiritual person how does that express itself in my life?" We all came to the same answer: making things. When we make things we are connecting to that part of ourselves that we imagine is the spiritual part, the part most resembling divinity.

I was incredibly moved by my experience as the officiant. I wanted to do it again. Clearly there was a need. I performed two more weddings in just that first month. In fact it seemed like everyone I talked to about their wedding, either previous or upcoming, was not happy with the officiant selection available to them. Why couldn't my creative, religiously dislocated friends find someone with whom they connected and shared their values to officiate for this incredibly important watershed moment in their lives? We deserved to have weddings that were meaningful and reflected our ideals as much as people who belonged to religious institutions. Why didn't we just start our own church? We couldn't think of why not to, so we did.

It was at this time that I was introduced to Tristy Taylor. Tristy had been doing performances as her alter ego, the Reverend Ms. Myrtle Motivation, between the sets at her friends' rock shows, encouraging the indie rockers to just go out there and be makers and doers. She had also been hosting "craft-ons" at her house near San Francisco, where a bunch of people would get together and make whatever they felt like making.

The moment we started to talk about this idea, a church of our own making, we were both drawn to it with intensity. We would get to make it all up from scratch. It would be more spiritual than religious.

We wanted it to reflect how important making and creativity was to our sense of our own humanity. We dreamed of a church that really could embrace a diversity of outlooks on spirituality, even atheism. We had completely internalized the DIY zeitgeist to such a degree that we didn't think twice about making up our own "religion." We made everything else in our lives with audacity, so this seemed like no big deal. And we decided to call it the Church of Craft. The name made us both giggle. But we couldn't have been more serious about our intention to make this idea a reality.

So I went home and invited everyone I could think of to a craft-on at my apartment. It turned out that everyone I talked to about the Church of Craft could identify with it. People said, "If I ever went to a church it would be one like this" or "I've always felt this way about making stuff; I never knew other people did too." By the next monthly meeting, the email I sent out had made its way around to people I didn't know, and they showed up for the craft-on too, thrilled to have found their people.

The meetings were playful and casual: conversations would naturally start around our projects and migrate to what was important in our lives. Projects would start with whatever we had brought and wind up with someone else's beads in it or inspiring someone else's color choices.

Something unanticipated was happening. Our making was becoming more important than the products of our craft. Artists who created for a living would come and just play, without worrying about whether or not what they made would sell. People who didn't think of themselves as artists could give themselves permission to try something that intimidated them, because it didn't matter if what they made turned out like the picture. Their creative impulse would still be valued.

Our enthusiasm proved contagious. In a very short time word of what the Church of Craft was doing spread to other states and even other countries. People started emailing Tristy and me to ask if they could start a chapter in their city. Our feeling has always been that

the Church of Craft belongs to its community, not to us. So we said, "Go for it!" Before we knew it there were chapters all over, and people crafting together for the love of doing it.

Of course Church of Craft wasn't the only group drawing crafters together, stitch-and-bitch knitting circles and other craft clubs of all kinds were becoming populated with tattooed and bespectacled young crafters who were ready to embrace hand-making with verve. Alternative "not your grandma's craft" fairs began to sprout up all around us. The mainstream took notice and told our story to sell their newspapers and magazines to the majority of Americans who were befuddled by our fanaticism for what they saw as a "hobby." Talking about the Church of Craft became a way for the rest of the country to understand how making things ourselves was a lifestyle choice, something that permeated everything we did, as it had affected my mom and the generation of '70s crafters who were her peers.

I have learned so much from the Church of Craft. I've learned that in our capitalist society bigger isn't always better: a meeting is still great and serves its purpose if only one or two people show up. Growth and progress are also mirages of accomplishment; being present here and now are the things we really need to worry about. Consumption eats self-esteem; creation makes it grow. I've written and said this so many times, but I believe it strongly: making things makes us happier, more whole people. I continue to be challenged by this incredible creature Tristy and I created, and I never know where it will lead me next. But I know that however it manifests itself, and whoever is involved in it, the Church of Craft will always mark a place I want to be, where we can come together and affirm and inspire each other.

JW & Melissa Buchanan

THE LITTLE FRIENDS OF PRINTMAKING MILWAUKEE, WISCONSIN WWW.THELITTLEFRIENDSOFPRINTMAKING.COM

As the Little Friends of Printmaking, we design a lot of posters. That is where we got started. We still hand-silkscreen all of that stuff, but now we have branched out into web design, animation, toy design, and illustration and graphic design.

We don't draw lines between "art" and "craft." Some people think the word "craft" has an anti-intellectual connotation. They think that if you are not creating a conceptual piece of art, then you are making a quilt. But "craft" covers a huge spectrum of intellectual pursuit.

There needs to be a different word for what we and other makers do than "craft" because "craft" has horrible connotations that aren't true. The word besmirches work that is really important. Some people don't want to identify themselves as artists unless they are very traditional artists. We almost don't consider ourselves crafters, we are more craft enablers. We operate outside of and parallel to what's going on with craft. And there are definitely elements of craft that cross over into what we do. We see a lot of the influence of craft in design, and we pick up on that.

To be honest it would never have occurred to us to be involved with the craft scene if we hadn't been hired to make posters for Art vs. Craft. Once we were there it was great, it was fantastic. Craft people and makers have the same rules that we have, and there shouldn't be any separation between us. If anything, our presence at the fair creates a context that puts the work that makers are doing in the right light so that people will understand what the work actually is. We almost wish that used-record vendors were at craft fairs and that there was a band playing so that people would know they weren't going to find snowmen made out of Styrofoam balls with nutmeg buttons. They would know this is something different. This is something cool.

Interviewed at their home in Milwaukee, Wisconsin.

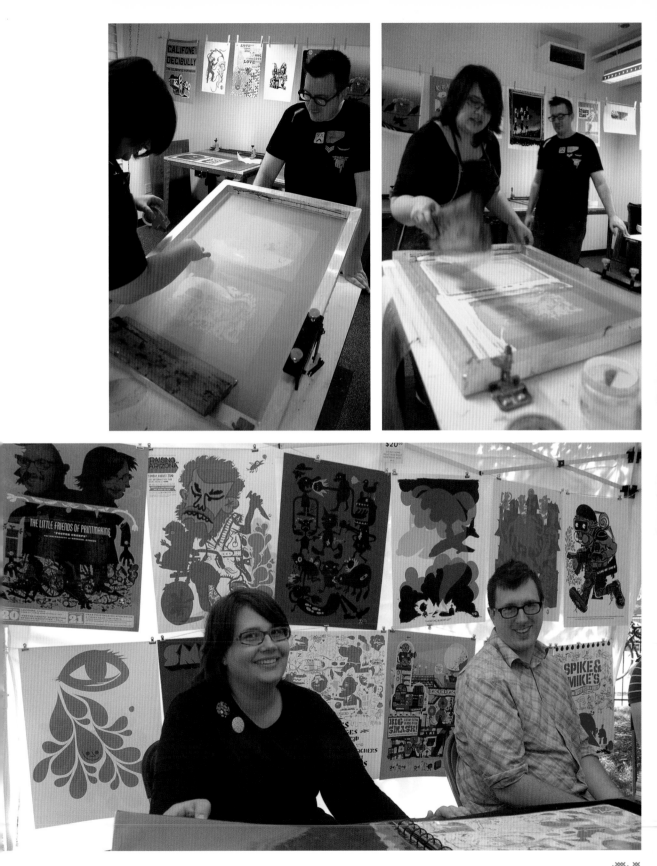

"AVENGE ME, BLOCKHEAD!"

Emily Kircher

EMILY KIRCHER RECYCLING ARTIST (EKRA) MADISON, WISCONSIN WWW.ETCHOUSE.COM/EKRA

I take things that are discarded and transform them into functional items. All of my purses and rugs are crocheted from recycled fabrics like old bathrobes or linens. These materials make really durable and machine-washable products. I also make magnets from old bottle caps and pictures from vintage kid's books. I mosaic picture frames with old cups, bottles, and plates that I cut up.

I think that I tend to attract a younger customer, but there are aspects of my work that appeal to a very broad range of people. Some of my designs are very plain, and I think they remind people of an older time. At every craft show people come and tell me that their grandmothers used to make rugs like mine and that my stuff reminds them of when they were kids. I have had a lot of different people buy my rugs, so they are definitely not just a young person's type of a thing

I was always crafty but I went to school for science. I decided that it wasn't for me and I would rather see the effects of my work more personally than be locked away in a lab. I knew how to crochet but I could never make anything big enough because yarn is so small. When I started using fabric it worked so much better for me. I like to make big things and I like to make tough things and strong things, and so with fabric, my crocheting just took off.

I have a very supportive family and husband, so it works out well. We have pretty much everything we need. We are not rolling in it; I am never going to get rich doing this. But I am happier than I have ever been in my life, so it is definitely worth it.

Interviewed while vending at Art vs. Craft in Milwaukee, Wisconsin.

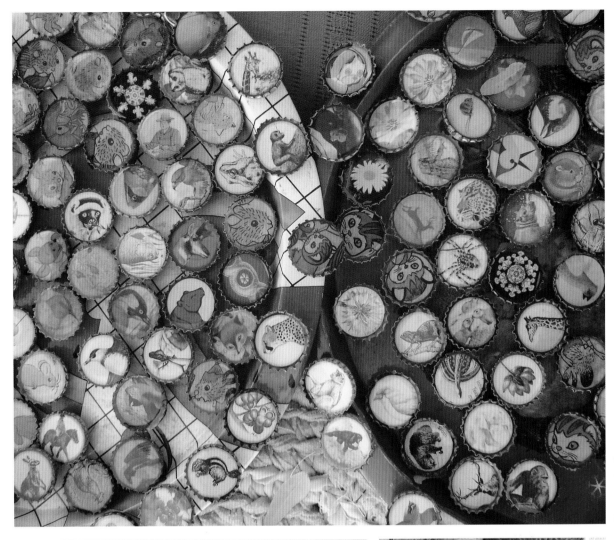

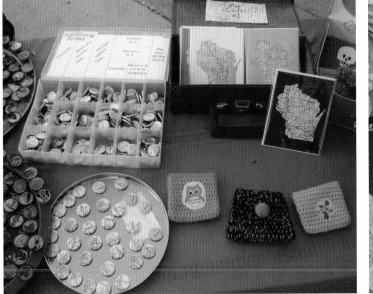

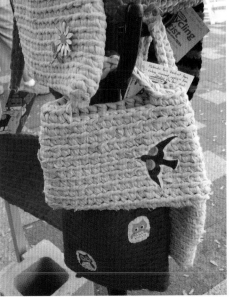

Melissa Dettloff

LEKKNER YPSILANTI, MICHIGAN WWW.LEKKNER.COM

Making turned into my business around 2002 or 2003, mostly by accident. I was out of college and working a lot, but making things in my spare time—more things than I needed for myself. I decided to open a little online shop, called Lekkner.com, mostly as a project to focus on in my spare time. The response was amazing and unexpected. Something I started in my bedroom opened up so many opportunities to travel, speak at conferences, be in *Time* magazine...It still blows my mind.

For a while I was making clothing out of thrifted T-shirts. I turned mostly animal-printed tees into hoodies, dresses, skirts, jackets, bags, and other things. I liked the challenge of limiting myself with my materials—knowing I had only so much fabric to work with meant I was doing a lot of problem solving on a regular basis.

Currently I run Crafters for Critters, where handmade donations are collected and sold online. All of the proceeds go toward animal rescue organizations. Through Lekkner, I got to know a lot of people that make things and I had the idea of trying to collect donations and then sell them to raise money for animal rescue. It wasn't something that I thought would last more than a couple of months. I was just going to get this one batch of stuff and sell it and that was going to be the end of it. Instead, there was such a good response that I kept it

going. It started in early 2004 and now we have raised close to $20,000 and have benefited over twenty organizations.

Interviewed while vending at Renegade Craft Fair in Chicago, Illinois.

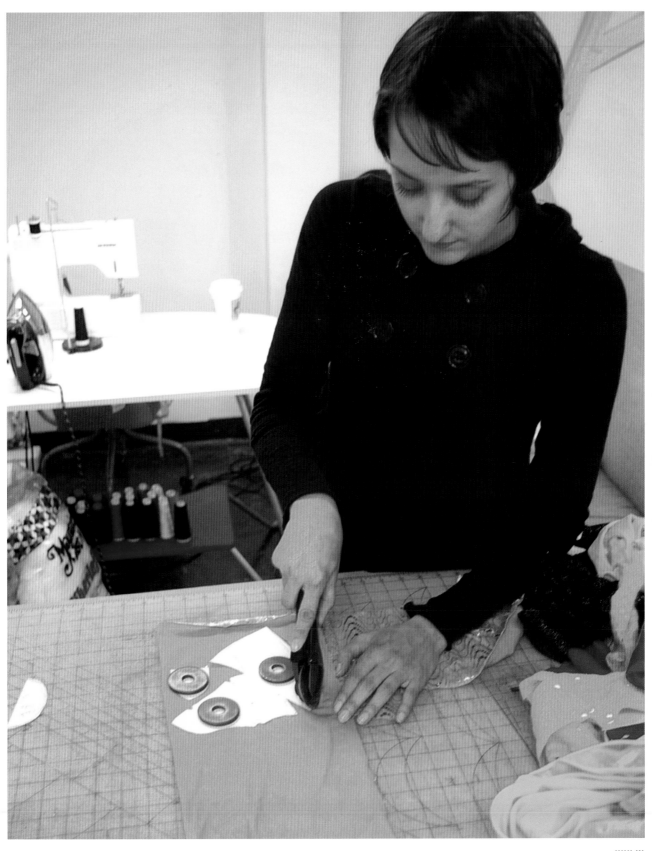

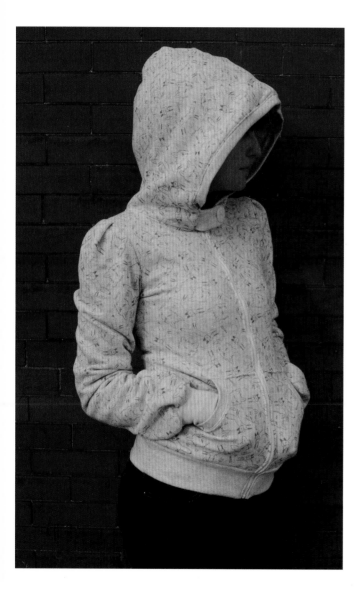

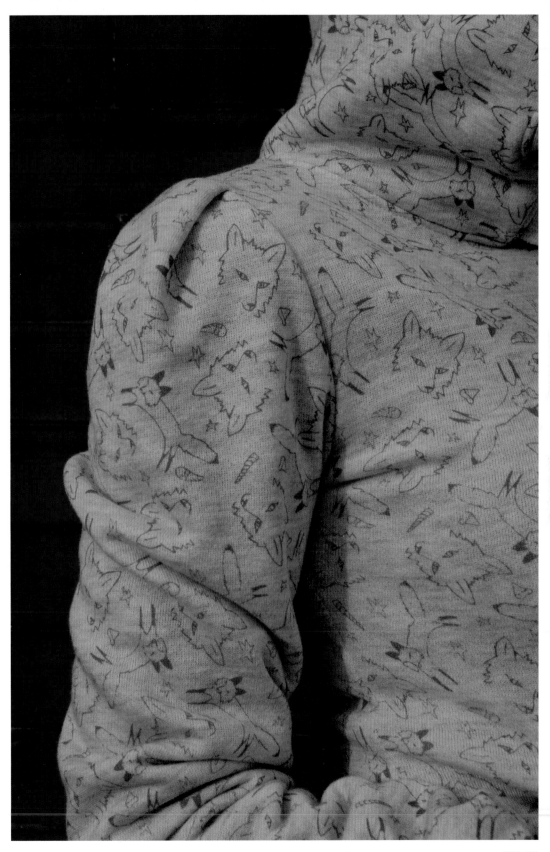

Sue Daly

TIMBER! CHICAGO, ILLINOIS WWW.TIMBERHANDMADE.COM

I was first introduced to crafting by my mom. She was into all sorts of needle arts and was always doing cross-stitch, needlepoint, and crocheting. She bought really cool folksy clothing and jewelry, too. She used to take me to this neat little bead store, and I would buy beads to make necklaces.

When I graduated from college, I started making jewelry again, just for fun. I was working as a waitress, and making jewelry made my life a little more fun and productive. I started wearing my own pieces, and my friends, family, coworkers, and even customers started to notice and compliment me on my handmade items. That's when I got the idea to sell my jewelry at art fairs here in Chicago.

When I couldn't find a show to apply to, because too many were geared toward fine artists and didn't allow crafters, I decided to start the Renegade Craft Fair with a childhood friend. We knew there was a growing DIY craft scene online and thought it would be fun to throw an event that embodied the DIY spirit.

Our first event happened in Chicago's Wicker Park in September 2003. It was such a success and so much fun that we decided to make it an annual event. With its further success in 2004, and the lack of another fair like it on the East Coast, we decided to branch out and have a Renegade Craft Fair in Brooklyn, New York. So in June 2005 we held the event at McCarren Park in Williamsburg. Since then, the fair has just kept growing and growing.

For now, I'm keeping busy running the brick-and-mortar shop Renegade Handmade in Chicago, where people can buy handmade items all the time. We've been open since July 2007 and feature the handmade wares of some of the most talented crafters out there. This is really a dream come true for me. I always wanted my own store, even before the craft fair came about.

Interviewed at Renegade Craft Fair in Chicago.

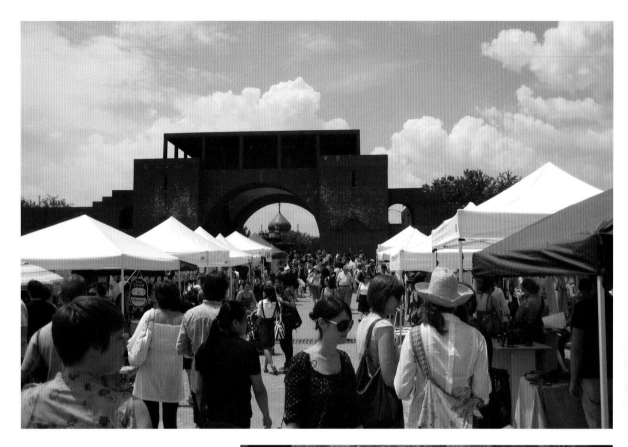

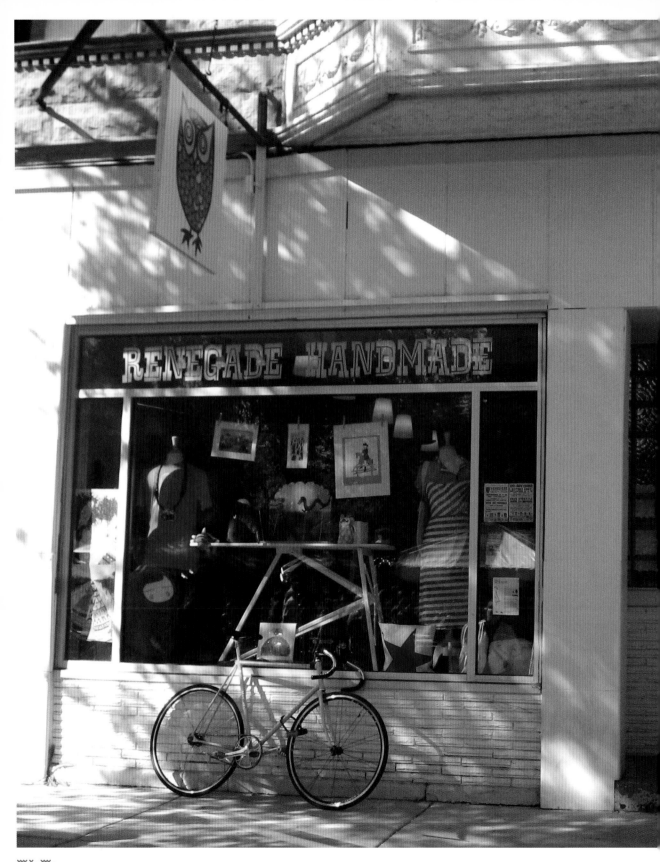

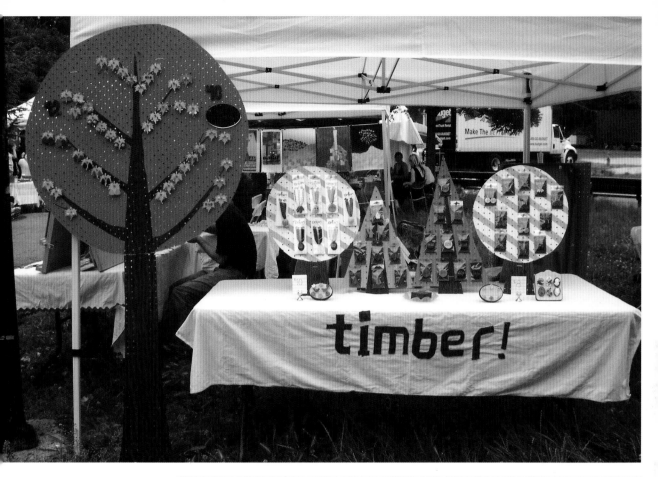

Annie Mohaupt

MOHOP CHICAGO, ILLINOIS WWW.MOHOP.COM

I always knew I wanted to have my own business. I constantly messed around with different ideas of what I wanted to make—bags, hats, clothing, or jewelry. Around 2000 or 2001, I started surfing around online to look at other crafter- and artist-run websites, daydreaming about the day I would come up with a product that was as cool and unique as many I saw on the web. That's when I became aware of the scene. I realized that there are a lot of people out there like me. I specifically remember seeing a poster for the first Renegade Craft Fair in 2003, and I told my husband that I would exhibit there someday. I actually launched my business at Renegade in Chicago in 2005.

Chicago has really embraced me and my business, mohop. I think that the fashion community seems excited about me building up the shoe industry. There used to be a lot of shoe factories in Chicago, and now less than 2 percent of shoes that Americans buy are made in the United States. Most of them are made in China, where you don't know what the working conditions are. Hopefully someday I will have a studio of twenty to forty people, but I would still like to keep it in Chicago.

I think people want things that are unique. As the world becomes more and more homogeneous, handmade things become more precious. Also, as people become more aware of issues like the environment, workers' rights, and toxic ingredients or materials in products, they are more drawn to artisan-made goods, which are purchases they can feel good about.

I really love to make shoes. I've always been a shoe person, and once I started experimenting with making them myself, I felt like they were the product I was looking for. It's kind of like when you realize you want to spend the rest of your life with your companion—it just feels right.

Interviewed while vending at Art vs. Craft in Milwaukee, Wisconsin.

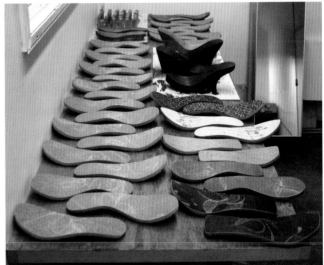

HANDMADE NATION

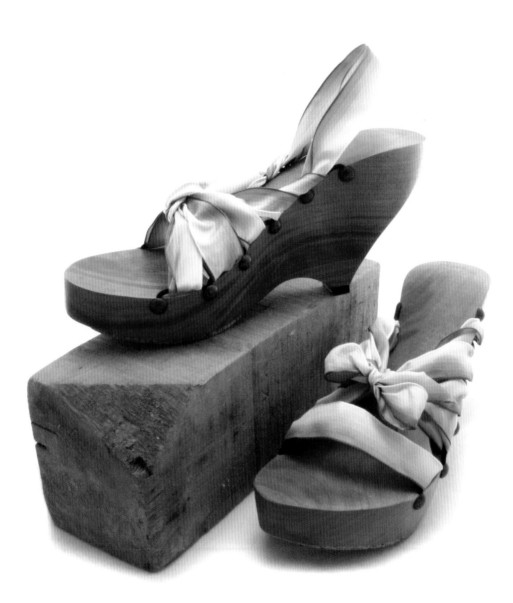

HANDMADE NATION

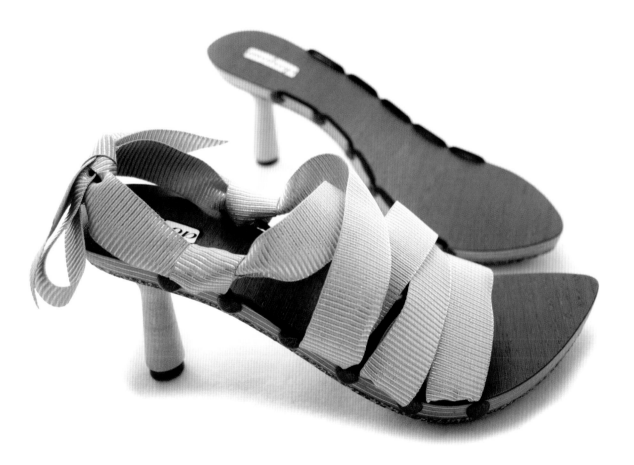

Activism Is Not a Four-Letter Word

Betsy Greer

After my stint in Girl Scout Troop #20 ended in 1986, I don't think I was crafty for more than ten minutes until the fall of 2000. While there were occasional camp-related or (kindly) grandmother-enforced dalliances along the way here and there, there was a giant fourteen-year craft drought in my life. But, to be honest, I didn't really care much, as I had words to play with instead of yarn and needles and buttons. I screamed out words on stage in performance art pieces, I wrote angst-filled poems in the middle of the night, I penned endless love letters to friends scattered across the globe and wrote reams of short stories. Words had become my playground, where I could step in and toss things around and run amok and experiment wildly and fiercely. I could write all night and burn it in the morning or hide it for safekeeping. Writing was my safe haven, my secret, and my most trusted friend. But after almost a decade and a half, my hands craved more than just a pen or a keyboard and wanted something different to toy with.

To be honest, I was a bit shocked when my hands wanted to create something visual instead of verbal; it was as if words were betraying me. I had just moved to New York City and was looking for a job and my hands weren't writing and, as happens every once in a while in life, I was a bit lost.

So I started walking.

I had no money. I lived in a giant new city and had friends who worked while I was looking for work, so I started out at first by drawing a sad little map on notebook paper with a pencil. In an attempt not to get too lost, I drew my tiny map while looking at a real map, finding a street in each direction to act as a border. I figured by keeping myself in a tiny radius, I would have the freedom to look around, but an invisible fence of sorts to keep me from getting lost. Never one before to consult a map, and eternally getting lost no matter what the mode of transportation, I thought it a good idea to establish some boundaries, even if they were self-imposed.

Armed with my sad little map and a whole heap of time, I literally put on my walking shoes and got to it. I discovered the piers on the Hudson, a new record shop that sold only vinyl, a natural food store, and tiny patches of grass that reminded me of home, along with many, many other small and seemingly normal everyday things. With my boundaries in place written in pencil in my pocket, I wandered around and around, excited to see what the turn of each new corner was going to bring. I was wide-eyed and curious and determined to explore. Instead of focusing on where I was going, I was focusing on where I was, which allowed me to soak in my surroundings like I was a sponge, delighted and energized by the tiny joys around me.

After a few months of exploring the city (I did eventually get rid of my little boundary map), I got a job at a publishing company and found myself in a cubicle answering phones. Now that I wasn't writing, it seemed like the ultimate mockery to be surrounded (very literally) by books and production schedules. No longer able to seek out new parts of the city during the day, and still unable to write, my hands needed something to sate them.

I decided I needed to learn how to knit. It was easy to learn, portable, and would keep my hands busy. I asked my coworkers if they knew of anyone who could teach me to knit. For some reason, the thought of learning something new that I could continue to improve on for decades and learning something that would bring me solace

when I was alone and keep my hands busy when I wasn't was exciting. I was sure that my new coworkers would wonder what was wrong with me, as knitting was at this point neither hip nor cool. As it turned out, one of them knew someone who was in a knitting circle. And just like that, I called them and soon I was on my way to my first knitting group. For a while, my hands were really happy—they stitched while my eyes watched bad television and my mouth chatted with friends after dinner. But somehow, there was still something missing. I had the city and the knitting and knew that something was pulling them together, I just wasn't sure what.

Even though I wasn't writing, my brain was going full speed with the walking and the building of books and the knitting. I tried to wrap my head around difficult stitches like I was trying to wrap my head around where all these things connected. But somehow they never seemed to connect no matter how much I thought or questioned or theorized.

Eight months later, I was back in North Carolina, with my knitting, my cat, and a new relatively boring temporary job. Due to New York rent-control laws, I had been given ten days to get out of my aunt's apartment. Still a bit stunned about how I had ended up down South again so soon, I pulled out my knitting, which I had abandoned thanks to the ridiculous heat and humidity that descends on North Carolina for (seemingly) most of the year. And there I was again, with my knitting, wondering what the hell was the significance of it all. This time around I had no television, and as a direct result I had more than enough time to think. It was here that I started to connect the walks and the knitting and my surroundings back up in New York City in earnest.

While I was in New York, I had the chance to watch the Greenwich Village Halloween parade and had found myself thoroughly enchanted by people deftly maneuvering giant puppets dressed as political figures down the street. They created a very visual representation of their disagreement with the government. I had always been passionate about social and political issues, but had

never quite felt comfortable marching or signing petitions or passing out leaflets. While those more traditional and time-tested methods of dissent have their place, they never felt right for me personally.

So gradually, with all this newfound free time (yet again), I began thinking about ways I could visually represent my anger and frustration around certain contemporary issues. I wasn't writing, I wasn't walking, but I was knitting. As I improved, the rhythm of the stitches quieted my mind and amazingly allowed thoughts to flow and mingle instead of sprinting on through. It was then that I began to realize that maybe there really was more to the knitting than just the creation of warm and cozy things. It was then that my mind bounced between the act of knitting and craft and the power that those puppets still held in my mind—that harnessing of dissent in a nonconfrontational way.

I started thinking about ways to knit for the greater good, and I realized that right now, right here at this very moment in time, the act of craft is political. In a time of over-ease and overuse and overspending, I can take back the control over where my money goes, over what my outfit is, and over how my life is lived.

I could knit my own clothes, thereby dictating my own fashion sense instead of following someone else's. I could spend money on ethically produced products and weed out the not-so-savory companies that were branding everything in my house from toilet paper to spices. I could knit blankets and vests and hats and scarves (as well as other things) for people who could really use them, both in my local community and abroad. I could stand up as an activist without having to stand on a street corner with a sign. I could start to change my life and make smarter choices and find partners in (crafty) crime and slowly change my life into one that's still fighting for change, but in a positive caring way instead of via anger. My friends and I could start a revolution—just by making things one stitch at a time with needles and machines and patches.

With this also came the realization that my little pencil-drawn map was my first act of activism, by daring to seek and explore

instead of just simply taking, and that first knitting group my first act of craftivism, combining crafts and activism. Every day can be lived as a testament to our beliefs and ideals, every day can be our own political march. Every day we can draw our own maps and design our own wardrobes. Every act we change and revise to better align with our conscience is an activist act, as it is making a step toward a more positive environment.

So now, when I unravel a thrifted sweater to make a new one, or walk instead of drive my car, or turn off the television and turn my records up, or talk with someone about how they can work toward making the world a better place, I am stitching tiny moments of activism and kindness into the fabric of this untamed world. And it is my hope that you'll join me, and we'll continue to wander and explore and be wide eyed, leaving points of conscience and activism in our wake, with every footstep.

SOUTH CENTRAL

JENNY HART

SUBLIME STITCHING AUSTIN, TEXAS WWW.SUBLIMESTITCHING.COM

When I started embroidering, I really got obsessed with it. It was relaxing. I always thought it would be stressful to embroider. It looked tedious, like it would make me want to pull my hair out. When I started doing it, it was better than drugs, alcohol, therapy—anything I had ever tried. I had been going through a really difficult time; I had several family members in the hospital. I was really looking for something that would curb my anxiety. Embroidery dealt with it better than anything else.

I did not grow up doing needlework, so when I started doing it I realized that it was easy and the diagrams were much more difficult. They didn't make any sense. I just kind of turned the directions on their head and made them very simple. When I started Sublime Stitching, I was really worried about the purists coming out and saying, "I can't believe you're showing them to do a French knot this way," because I really was taking it from a completely different angle. But traditional needleworkers just say that they are so glad that people are learning to do it, that the education is continuing.

A woman wrote me that she had tried to embroider when she was younger, and she showed her work to her grandmother. The first thing her grandmother did was turn it over and say the back was too messy. The woman wrote she never embroidered after that until she discovered Sublime Stitching and felt like she could try it again. There was this idea that embroidery must be perfect and the embroidery had to be held to a certain standard. I felt like that didn't apply anymore. Stitching is supposed to be something that can be enjoyed. Plus I don't think our generation really likes to be told what to do, or at least be told that if you are going to do this, it has to be done this way and you have to have these results. We really like to have a lot of wiggle room for experimenting and being creative, and we like to have our mark on it. Embroidery leaves a lot of room for that.

Interviewed at her studio in Austin, Texas.

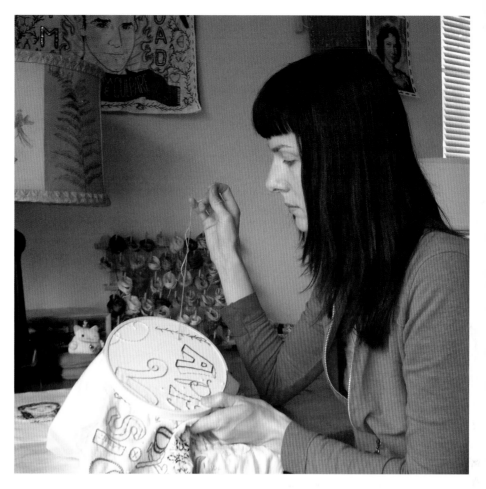

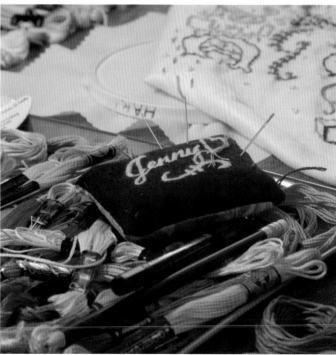

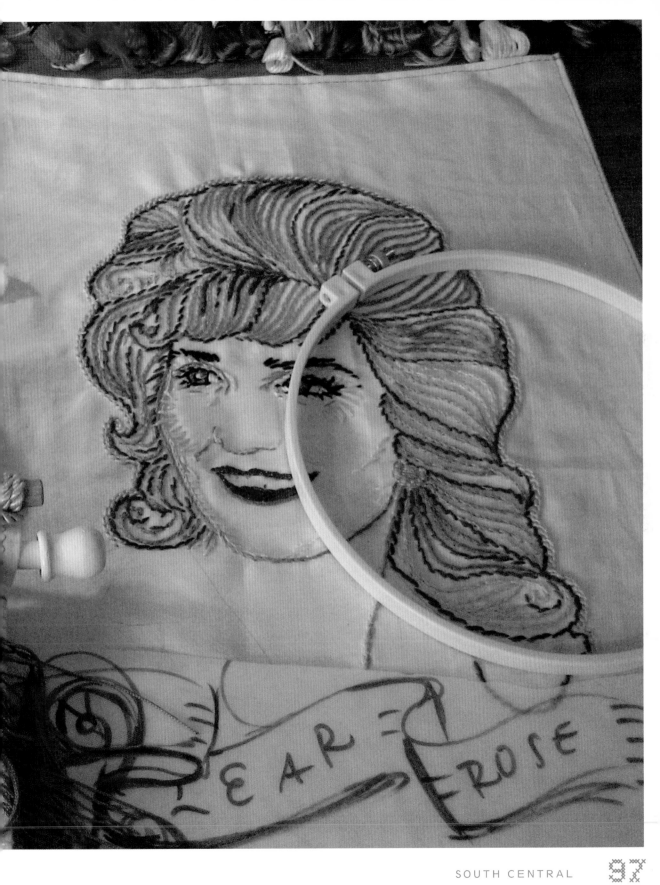

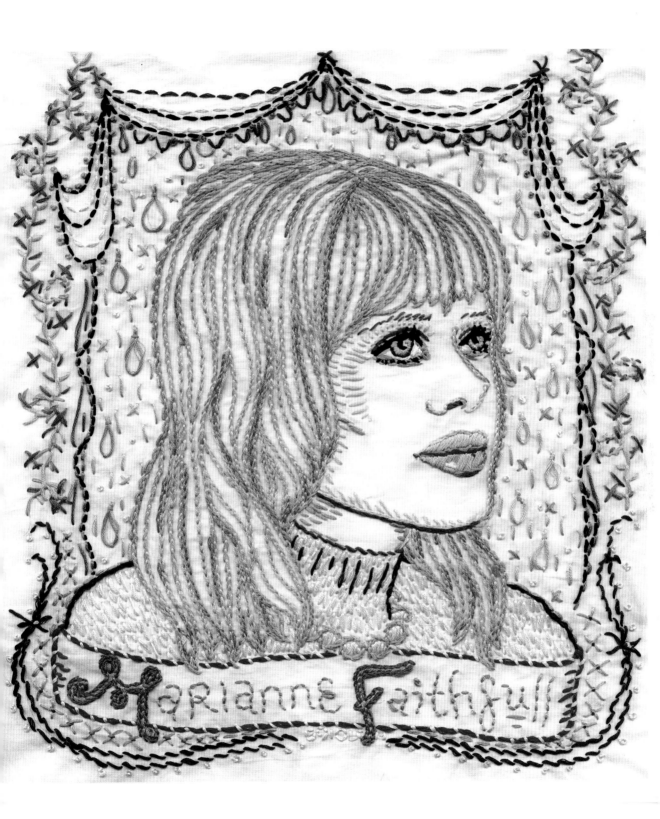

KNITTA

HOUSTON, TEXAS WWW.KNITTAPLEASE.COM

We take our knitted pieces out to the streets and we tag things like stop-sign poles, door handles, trees, and anything that we feel like tagging. Knitta started in August 2005, and since then it has taken off.

POLY COTN: "What are we trying to say? Well, not necessarily anything extremely verbal or political. Sometimes it's just that there is a lot of cement and steel that we are not very comfortable seeing on a daily basis. When we put something like a colorful polyester-acrylic six-foot wrap around a stop sign pole, people stop their usual routine and take a moment to see it and appreciate it. When they tell us about it, that's when we know we are communicating with our audience. I think that's powerful."

PURL NEKKLAS: "I like to feel like we are wrapping things with love. It's humanizing. We're adding a human element so you are not so disconnected with your everyday environment. Industrialization is everywhere in urban areas, and pinks and reds are a lot prettier than grays."

MASCUKNITITY: "Knitta mixes this warm coziness with a dangerous urban edge. I think a lot of people enjoy that. That's the novelty of it. It's knitted stuff within a quirky context."

P-KNITTY: "When we tag, if our targets don't like it they can just cut it off. If it's on their car antenna or their tree, they can just get rid of it. It's not like we're painting. It's not vandalism."

POLY COTN: "People don't know how to react to our tags. In fact, when people ask me about it while I am installing, I just come up with random reasons for what I am doing. One time I said that it was for a scavenger hunt for a church youth group. I used that one in New York on a cop. I don't think anyone knows what to think of it. It doesn't look like we are doing anything malicious or awful. Whenever you see a hand-knitted anything it means that there is something loving that is going on."

KNITTIA: "Sometimes it is a kiss of some sort. We love you, we are going to tag you."

Knitta was interviewed in Houston, Texas.

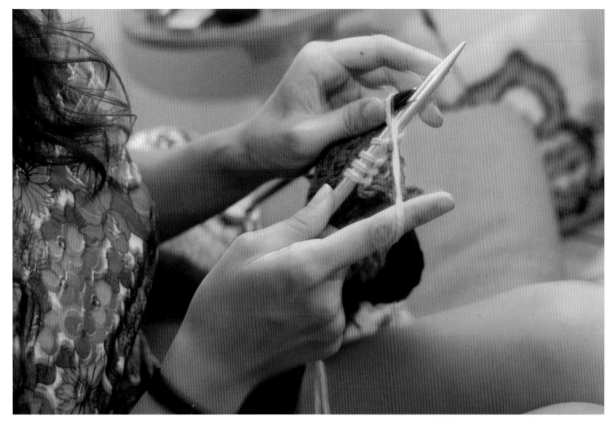

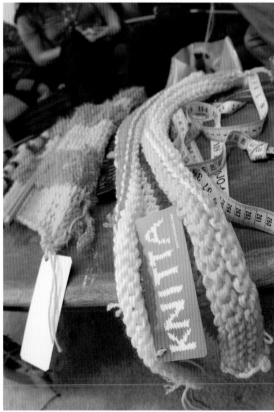

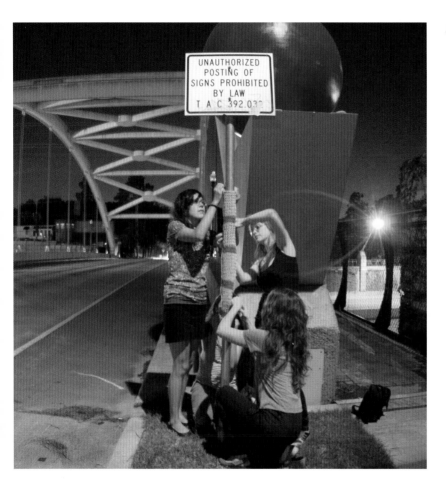

The sign reads:

UNAUTHORIZED
POSTING OF
SIGNS PROHIBITED
BY LAW
T A C 392.03?

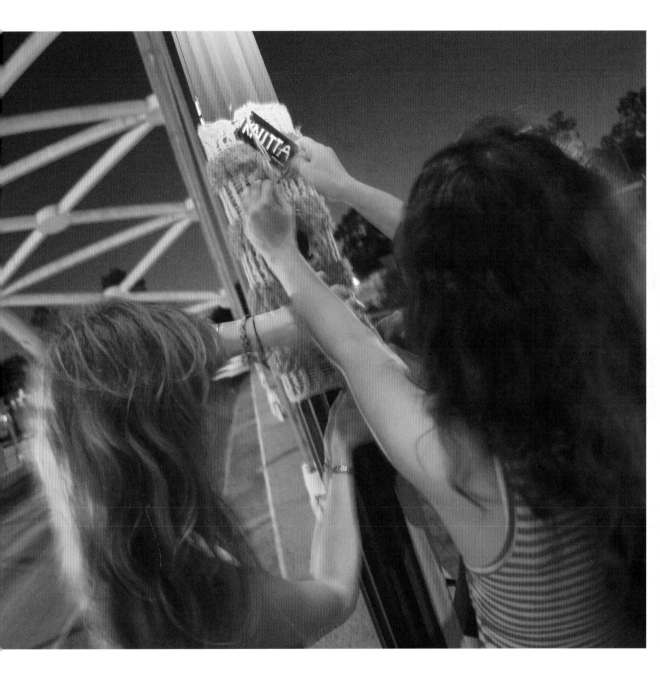

WHITNEY LEE

MADE WITH SWEET LOVE AUSTIN, TEXAS WWW.MADEWITHSWEETLOVE.COM

Made with Sweet Love came about when I started making artwork out of latch-hook rugs. Many people could relate to my art on a personal level because they used to make hook rugs themselves. There were a lot of people who hadn't seen much art before, but this art meant something to them. It was accessible. It wasn't like I had incredible painting skills that they couldn't relate to; this is latch hook. They could do this, too. When my prices went up, many people could not buy my work. Made with Sweet Love allowed people to purchase a kit and do the latch hook themselves. That way they could still own the work for an affordable price.

When I started making the work, I was getting my degree in photography and I was working with digital photography. I came up with a method to use my hands and to feel like I was making something, instead of simply pushing a print button and having the piece of art come from the cold machine in the corner of the stuffy computer lab. The question of whether my work was art or craft came up right away. It went beyond the suggestion that a man's work is art and women's work is craft; it was more of a question of what the work was distinguishing. When I chose an image of a reclining nude for a rug, it was meant to reference reclining nudes from art's history. The image happens to be taken from pornography, but I definitely wanted to have it relate to art historically. At the same time I like that it references women's artwork that was created to be placed on the floor and walked upon.

The question "What is art?" is art-school philosophy. When I show my work, I don't think anyone would say that it's not art. When it is in a gallery context, if I say that this is art then people roll with it. It is art and it's crafted, but there is meaning behind it, so it's art to me.

Interviewed at her home in Austin, Texas.

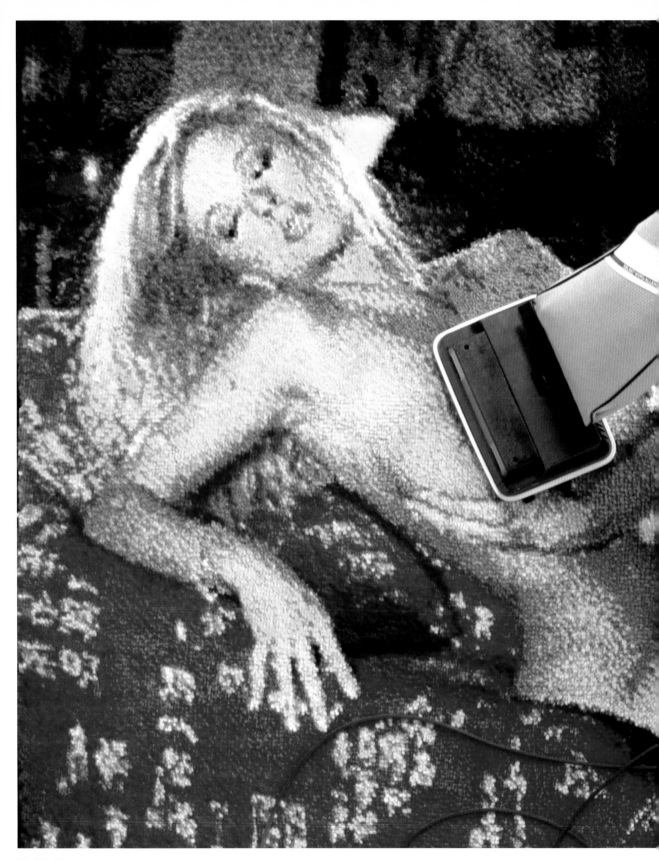

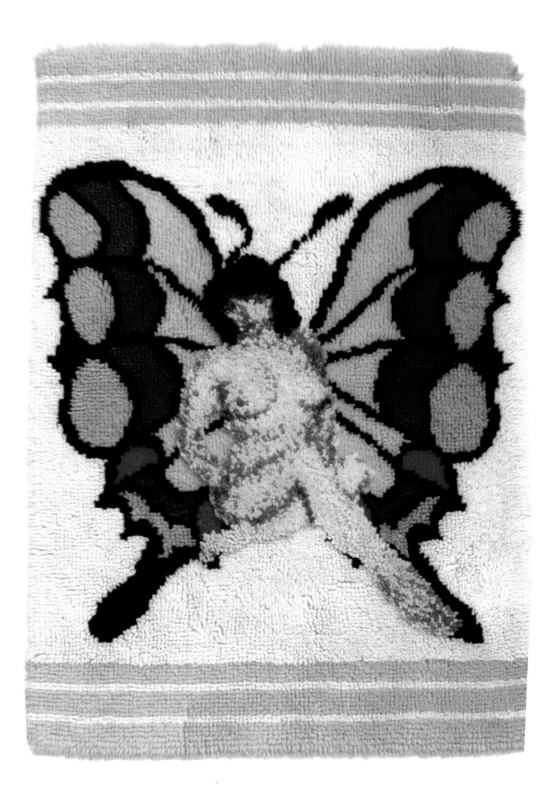

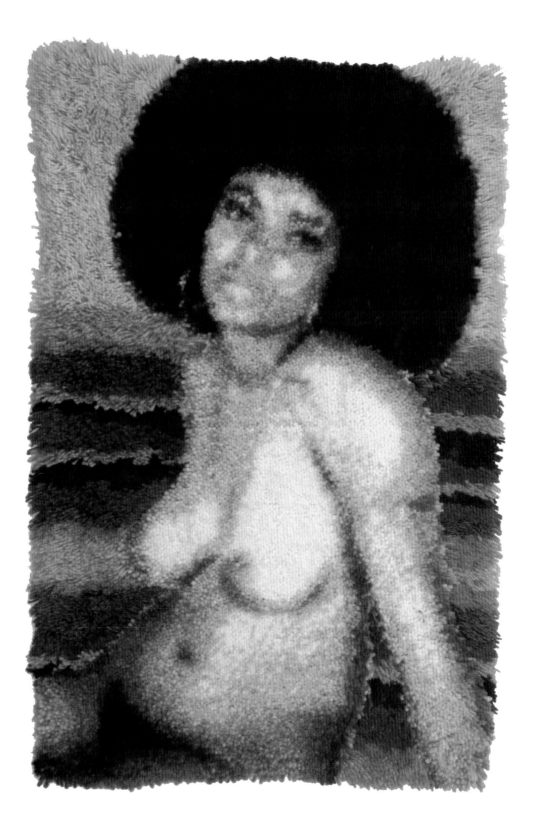

SOUTH CENTRAL

KATHIE SEVER

RAMONSTER AUSTIN, TEXAS WWW.RAMONSTERWEAR.COM

I feel like the resurgence of craft, for me, came along in a really pivotal time in my life. I went to art school and I thought I was going to be a painter. Then, when I was going through the process of applying to graduate school, I went to Montana to take time to figure out what I was going to do and where I wanted to go with my painting and try to figure out the language of the art world. I was becoming more and more disillusioned with the whole thing.

In art school, I was in this bubble where I did what I wanted and my professors patted me on the back and I wasn't expected to sell my art or come up with a cohesive body of work or talk about my grand plan for what my art means in a bigger sense—at least not at the art school where I went. When I moved to Montana there were all of these people who were so far removed from the art world, but who were infusing everything that they did with this amazing creative flair. To me, if felt so much more solid and real to put my artistic intent into something that was then going to become integrated into someone's life on a daily level. Then all of a sudden there were a lot of people my age who were coming from this art-school background who were wanting to make usable items. I think that is where the current DIY movement was born.

The launch of my business, Ramonster, coincided with the birth of my daughter Ramona. It started off as a children's clothing company. Since then, Ramona's grown up some. So has Ramonster. Now Ramonster features one-of-a-kind indie-Americana-themed clothing for men, women, and children.

Interviewed at her studio in Austin, Texas.

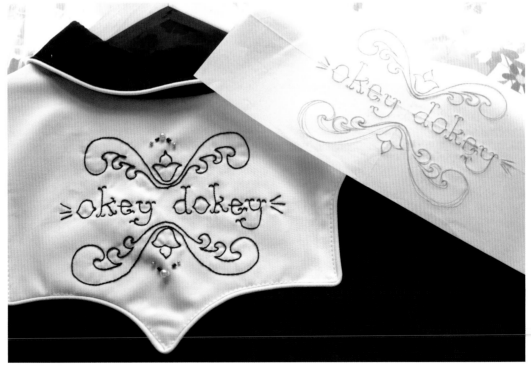

JENNIFER PERKINS

NAUGHTY SECRETARY CLUB AUSTIN, TEXAS WWW.NAUGHTYSECRETARYCLUB.COM

I have always made things in some shape or form. I started making jewelry when I was a child, and I began selling it at family garage sales when I was in junior high.

In high school, I had my first serious experience with making when I started my paper zine, *Scratch-n-Sniff*. I barely knew how to use computers, and so I made the layout cut-and-paste style. My friend worked the night shift at the Holiday Inn, and I would sneak over and print copies there.

Somehow through snail mail (this was way before email), I became connected with people all over the country. I would ship zines off to Canada, Florida, and all over the Northwest. This was when the Riot Grrrl scene was huge and I was obsessed with it, too. It taught me about making something in bulk, fulfilling orders, and shipping things. It introduced me to the DIY scene.

After college, when I was a secretary with a lot of free time, I started an online zine called *Pink*, which eventually became the website Naughty Secretary Club. NSC started as a zine with band interviews of people like Cursive and Spoon, articles on how to spray paint your shoes and match your purse to your outfit, and recipes. It was a hodgepodge of who and what

I was: a girl who loved music, writing, crafts, cooking, and dressing up in pretty clothes. Eventually I started selling jewelry on NSC, and the zine disappeared. But, I always think of *Scratch-n-Sniff* as my introduction to the world of making.

When people ask me what I do, I typically say I am a jewelry designer with an online store. However, there is a lot more to it than that. I coproduce the Stitch Fashion Show and Craft Bazaar. I usually don't bust out with the fact that I am a TV host because people always look at me like I am lying through my teeth. But every weekday they can tune into the DIY Network to see my smiling face crafting along with them. I am an Austin Craft Mafia member, and I recently added author to my many job titles with my new how-to book, *The Naughty Secretary Club: The Working Girl's Guide to Handmade Jewelry*. I also have a crafty consulting firm that Vickie Howell and I started called Craft Out Loud. Needless to say, I like to keep busy.

Interviewed while vending at Renegade Craft Fair in Brooklyn, New York.

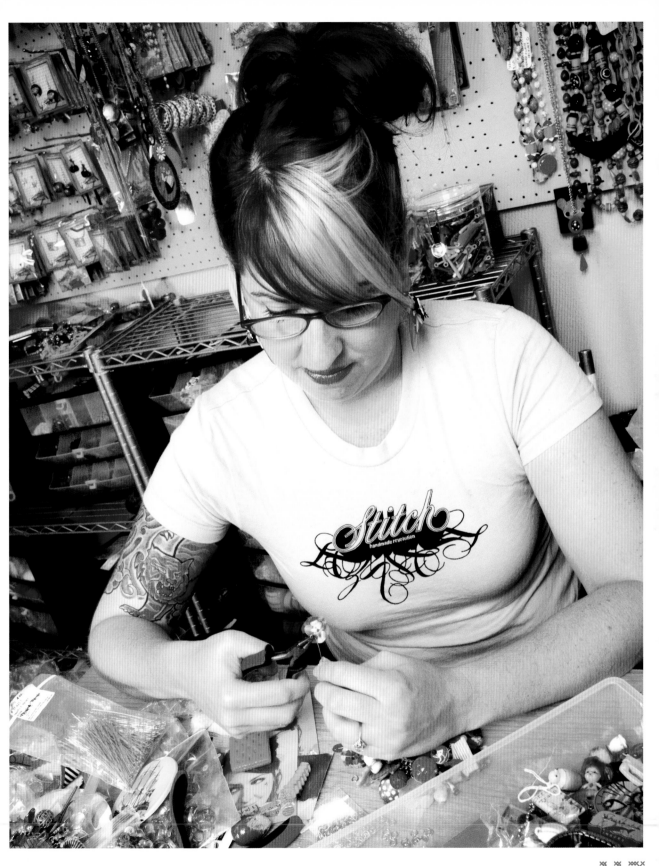

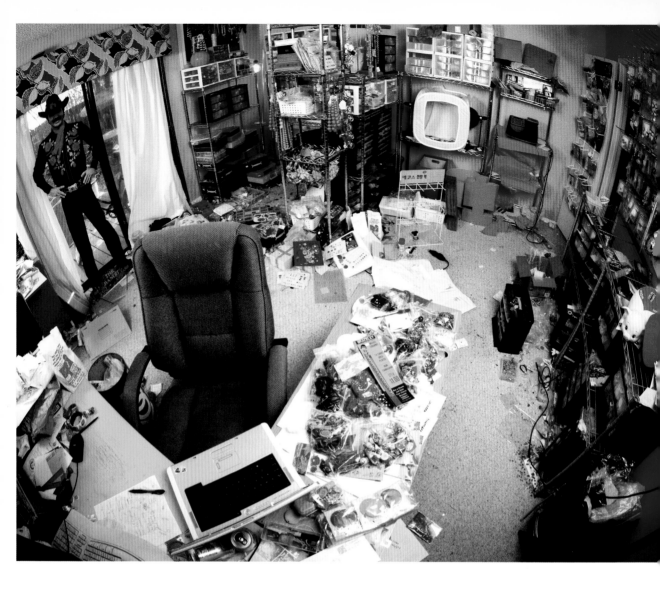

Craft Fairs Redux

Susan Beal

I grew up going to local church bazaars in the 1970s and '80s, admiring all the crafty knickknacks and toys for sale. I love that homemade aesthetic, and the craft events of my childhood were fun to attend, but the handmade fairs of the new wave of craft are simply stunning—small regional sales and huge national fairs alike. The handmade resurgence has truly raised the bar for crafting and for selling handmade work, and crafters themselves have created annual events that now draw hundreds of vendors and thousands of attendees.

As craft websites and message boards began popping up in the late 1990s and early 2000s, users began posting on these sites to organize and publicize local get-togethers and events. The internet became a powerful tool in the community, instantly linking creative people and making regional and even national event planning a viable and low-cost endeavor. Sharing photos and distributing flyers and information was easier than ever before, and when a fair started up, more people than ever flocked to it to look over and shop for crafty wares.

Leah Kramer, founder of Craftster.org, says, "The Bazaar Bizarre started in Boston in winter 2001 with twenty vendors in a VFW hall. I found out about it from a flyer I saw, and I knew this was something I wanted to get involved in the next year. I had just started to get back into making stuff myself and it was so refreshing to see all kinds of crafts that were hip and funny and irreverent—for example, one guy's craft was to recreate rock album covers by gluing colored macaroni

to cardboard." She became a vendor the following year and has co-organized the event ever since.

Sue Blatt and Kathleen Habbley organized the first Renegade Craft Fair in Chicago in the spring of 2003. Kathleen says, "At first, Sue and I were looking to join a fair to sell our handmade wares but couldn't find anything that suited us. We were big fans of online sites like Cutxpaste.com and the crafters profiled in *Venus*, but there hadn't been a big, national fair yet that catered to the new crafting scene. Just on a whim, we thought, 'We should start our own.' It was a lot of hard work on the business end, but it seemed like word of mouth spread instantly about it and we received applications from all over the country and even Canada." By the second year, Renegade expanded to a two-day event to meet demand. It added a holiday event in 2006.

Jennifer Perkins co-organized the first Stitch Austin show in fall 2003, which spotlighted work from nine runway designers and twenty-five craft vendors and has grown in just five years to sell out the Austin Music Hall with seventeen runway designers, one hundred vendors, and a rotating selection of make-and-take booths for shoppers. She says, "Stitch was one of the first shows to combine music, fashion, and crafts into a big nightclub-like activity, where everyone is shopping, taking in the fashion, listening to the music, and enjoying a cold beer." Stitch gives away a small business grant annually, supported by raffle ticket sales.

Gallery owner and craft designer Faythe Levine started the semiannual Art vs. Craft fair in Milwaukee in fall 2004, intent on bringing new work to her town. She says, "We want to be welcoming to everyone, so we focus directly on our vendors and connecting with the community." Around the same time, Christy Petterson was participating in monthly mini-sales in Atlanta and wishing someone would organize a bigger event like the ones she heard about in other cities. She met fellow crafters Shannon Mulkey and Susan Voelker over dinner one night. "By the time we parted ways that evening we had a name—Indie Craft Experience—and a basic plan for a summertime event that would include a craft market, fashion

show, live music, charity raffle, art show, and guaranteed good time!" Christy adds that ICE has always doubled as a fundraiser for nonprofit organizations, donating to local shelter Hagar House and Hurricane Katrina relief effort Crafters United.

The spring of 2006 brought new craft fairs to two West Coast cities. In Portland, Cathy Pitters and Torie Nguyen started a monthly event in rock club Doug Fir. Cathy says, "We had been talking for a while about how Portland needed a regular indoor venue for artists and crafters to sell their work, but it was a year or so before we took the plunge and started Crafty Wonderland." Torie adds, "Having a juried sale is really important to us because we want to present an interesting mix of quality handmade items and art and avoid having too much overlap. We limit the number of vendors in each medium and carefully plan the booth layouts so it's advantageous for the sellers and keeps things interesting for shoppers, too." Each month Crafty Wonderland offers a different free craft project; past favorites have included mini shrines, snow globes, and cupcake decorating to celebrate the sale's first anniversary.

In Los Angeles, Jenny Ryan was also ready to create an event in her city. "The first Felt Club event came about due to my frustration with the lack of regular selling opportunities for folks like me who craft for a living. I knew of many farmer's markets and flea markets that would occasionally feature a handmade vendor, but there was no regular event focusing purely on crafts. This was especially surprising to me considering that LA is packed with creative and diverse people. So we've grown from being a small, monthly event with a few dozen vendors hosted in a parking lot behind a comic book shop to a highly anticipated biannual celebration with nearly a hundred vendors, plus food, music, and hands-on craft classes."

The publishers of *Make* magazine organized the first Bay Area Maker Faire event, which included a Bazaar Bizarre section and an array of free DIY workshops, in spring 2006 to launch the initial issue of its sister magazine, *Craft*. Bazaar Bizarre co-organizer Jamie Marie Chan says, "At Maker Faire, the attendee can explore science,

technology, art, craft, and the creativity that binds all these genres together under one roof. What other event can provide knitting workshops, Lego-built cities, clothing reconstruction, and dissecting mechanical frogs all in the same day?" *Craft* editor Natalie Zee Drieu adds, "The entire Maker Faire has its own energy of inspiration and making. Everyone's asking questions and taking part in workshops or just meeting each other."

The second Maker Faire, in spring 2007, attracted 45,000 attendees and included even more hands-on craft demos. Nancy Flynn, who led two sewing workshops, commented, "Teaching at Maker Faire was an incredible experience. I didn't know what to expect going in, and was blown away by the creative enthusiasm of the crowd, who ranged from veteran seamsters to people who had never picked up a needle and thread but were eager to learn. I was also so inspired by the other demos, and I wish I could have attended all of them. I met so many inspiring people and put faces to blogs I'd been reading for ages."

In just a few years, craft fairs have mushroomed into sustainable annual events, continuing to attract more and more vendors with remarkable wares for sale. Many of the fairs have expanded to new cities. Bazaar Bizarre now has events in Los Angeles, Cleveland, and San Francisco. Renegade hosts annual shows in Brooklyn, and Maker Faire has spread to Austin. Craft fairs like Stitch and Felt Club consistently sell out larger and larger venues. Leah Kramer says, "When the Boston Bazaar Bizarre opens its doors, people are lined up around an entire city block for upwards of an hour to get in. It's really the perfect marriage of happy creators and appreciative consumers."

Faythe Levine sold for the first time at the initial Renegade event and remembers the carefree "renegade-ness" of other sellers arranging their wares on blankets in the park. Now, she says, she instantly notices the striking sense of "handmade professionalism" crafters show in their intricate displays, tags, lighting, and designs at events. Sue Blatt adds, "The community is really supportive, too, and people are always trying to help each other by sharing ideas, tips, and

opportunities, which is a huge part of this movement. People are able to be successful running their own little cottage industries."

Modern craft fairs often transcend their original purpose of simply bringing sellers and buyers together. Christy Petterson comments, "At ICE, we want people to show up and buy tons of stuff, but we also feel like there is more to the experience. We want people to walk away inspired to try crafting themselves and to realize why it's so important to shop handmade." Jenny Ryan adds, "For me Felt Club isn't just about providing a great shopping experience, it's about providing an education—showing people why and how they should be interested in the handmade movement and how they can get involved, too. Helping people uncover their untapped creativity is a big part of the fun." And Jamie Marie Chan agrees: "Indie craft fairs have defined a generation of women and men who value the nature of handmade and innovative goods. Sure, we're a consumer-driven, materialistic, capitalist society. But these events reflect our ability to value both a handmade creation and the community that brings it to you. I have never felt more at home than in an indie craft fair. It's a place where our hobbies, our ideas, and our worldviews are packaged up into a tangible object to share, to be admired, and to start new relationships between people."

Jill Bliss

BLISSEN PORTLAND, OREGON WWW.BLISSEN.COM

I am an artist, designer, and illustrator—I make stuff.
I went to school at Parsons in New York and graduated
in 2000. I was in the illustration department, but was
also studying couture fashion design. I was handcrafting
things in my job working with small fashion companies,
and then I started incorporating that with my illustration
work in school. When I moved back to San Francisco and
I couldn't find a job, I just created my own website and
made my own job selling those things.

The themes that I work with are primarily things I find around me. After living in New York for five years, where I was constantly in a really dense urban environment, I was missing California and all of the plants and animals there. I spent my first six months back in San Francisco just walking around the city and going to the Presidio, which is a national park inside the city. There I drew all of the plants that I had missed. Because I am such a visual thinker, I have a really hard time remembering the names of things, so I drew native plants to try and remember their names.

I then moved to Southern California about an hour inland. It was really strange for me because I had lived most of my life right on the coast. I found myself really homesick for tide pools and costal life. An underwater theme developed in my work. I have just moved north of San Francisco where the redwoods start to grow. There is one in my front yard that I am really excited about. Everything that I draw for my shop at Blissen.com is from the natural world that surrounds me. It is really a huge inspiration for me.

Interviewed at Paper Boat Boutique & Gallery, Milwaukee, Wisconsin.

HANDMADE NATION

Nikki McClure

OLYMPIA, WASHINGTON WWW.NIKKIMCCLURE.COM

I started doing paper-cuts in 1996. I made a book called *Apple*. I was just sitting in my room one day, trying to figure out what to make for an upcoming art show. My partner asked, "Why don't you just try cutting paper?" I had wanted to make something black and white, but I didn't want to use linoleum, because it took too long and I always forgot to switch things over and then everything would be reversed and it would be really frustrating. I was doing scratchboard then, but people were scanning it and it just wasn't turning out right. So I cut a picture out and it was just one of those lightening bolt moments. It felt really good and I was really happy. Now I look at it and it is totally crude. I wouldn't have made it like that now, knowing all of these little things that I have discovered along the way.

So, ten years later, each picture is never perfect, but that is what I like about paper-cutting. I am kind of a perfectionist, so if I were drawing it with ink or something like that it would take me forever to do the picture, and I would get really stressed out. When I draw with a knife I make mistakes and I have to fix them or live with them. To fix them, I have to find new solutions—a different way of approaching the piece or something. If the last piece that I made wasn't perfect, then I'm inspired to make another piece. Here I am still trying to make the most perfect piece, but failing...luckily. Otherwise it would be all over.

Interviewed in her studio in Olympia, Washington.

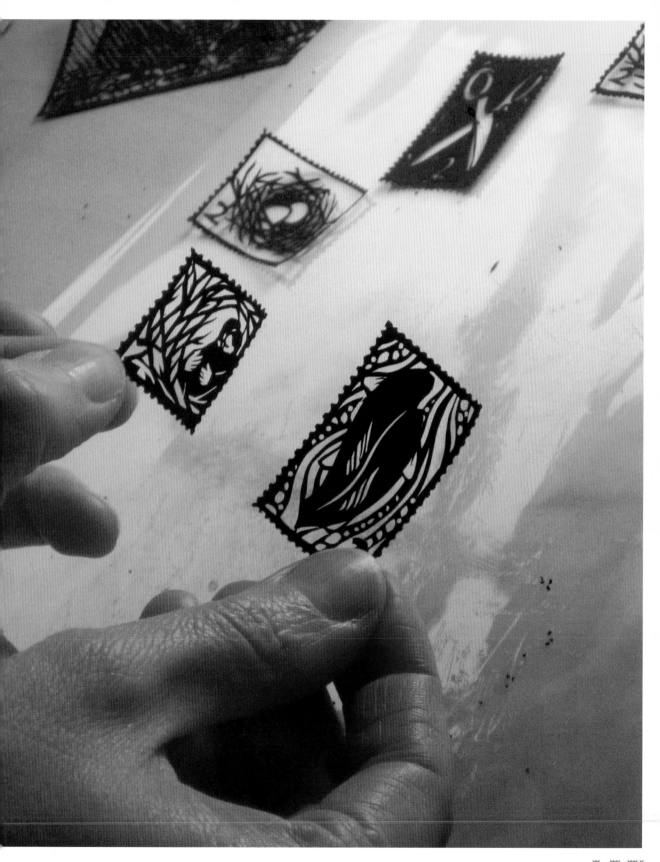

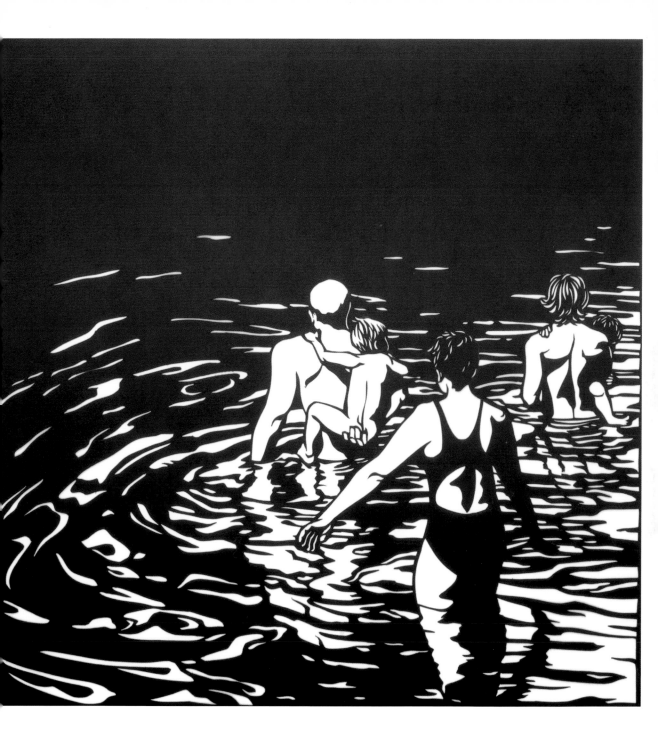

Clarity Miller

BLACKBIRD FASHION ANACORTES, WASHINGTON WWW.BLACKBIRDFASHION.COM

I have a clothing line and a stuffed animal line under the name Blackbird Fashion. I am passionate about the environment. Many of my stuffed toys are made from recycled wool sweaters, and all of my garments are made from natural fiber fabrics, mainly cotton and wool. When I design, I try to design for everyone. I make clothing in a range of sizes, with designs that would look flattering on a variety of folks.

I am driven by the ideal of supporting my family and myself through craft. Previously, the income from my stuffed animals and clothing has been secondary to that from my day jobs, which have been mostly uninspiring. I foolishly chose art as my college major, and although it is where my heart is, it is not where the money is.

When I was growing up, I watched my father go through the same process that I am now. He was a ceramic artist who made incredible sculptural tiles. Some were art pieces and some became counters and intricate floors in people's homes. It was from him that I developed the utopian idea that artists make beautiful objects, people buy them, and the artists and their full pockets live happily ever after. Sadly, many talented artisans have to put aside craft and adopt more "practical" careers, my father included. This shouldn't be! We should revel in the one-of-a-kind wonder of handmade objects. We should celebrate the people who make them.

The DIY movement is shunning mass-produced fare in favor of handmade goods. My generation of craftspeople is being revered in craft books, while new craft fairs and markets are springing up across the nation. With all of these optimistic advances, I'm positive that I can make it work. This year I gave birth to a marvelous son, Caspian. Like many crafty moms, I am trying to balance my child and my business, while both are growing. Making a living from my craft has always been my motivation to keep sewing.

Interviewed while vending at Urban Craft Uprising, Seattle, Washington.

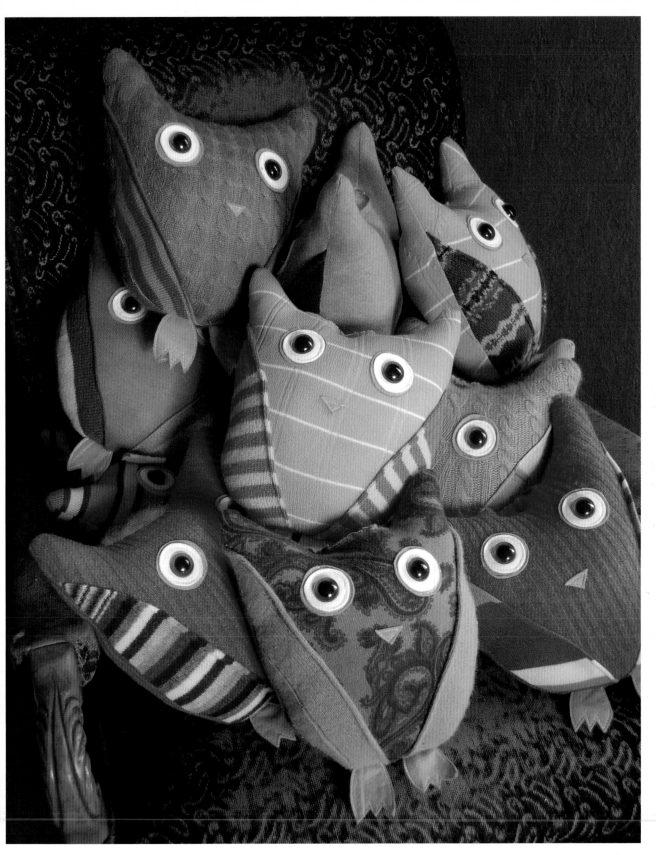

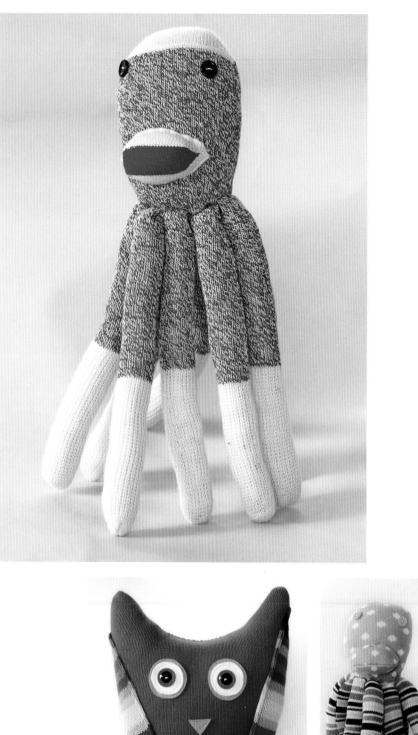

Stephanie Syjuco

ANTI-FACTORY SAN FRANCISCO, CALIFORNIA WWW.ANTI-FACTORY.COM

When I started Anti-Factory, I wasn't involved in the craft community. I actually wasn't aware of how broad the online craft community was, so it was a pleasant surprise when I found it. Anti-Factory started out as a conceptual art project. I was in graduate school at Stanford University, and I was wondering if I could make every item of clothing I wore by hand. I wanted to wear handmade clothes and be somehow "self-sufficient" and fall outside of the traditional production-consumption model of clothing manufacturing.

At the time, I was studying issues of sweatshop labor and consumerism and the industrialized process of how objects are made today. I wanted to start this project as a reaction to that, and from there it sort of took on its own life. People started asking me where I got my clothes, and so I expanded my work and started selling a couple items online. I was surprised by the good feedback. And so Anti-Factory was really accidental.

Anti-Factory has the tag line "Because Sweatshops Suck." I use that line because it's straightforward and it automatically positions Anti-Factory as having a political stance as well as a creative stance. When I looked at other people who were making clothing and affiliating with the craft scene, they sometimes talked about politics on a subconscious level, but they didn't necessarily state their ideas up front. I wanted to make mine apparent. Because each item is unique and handmade, it goes against the grain of mass manufactured products.

Interviewed at her studio in San Francisco, California.

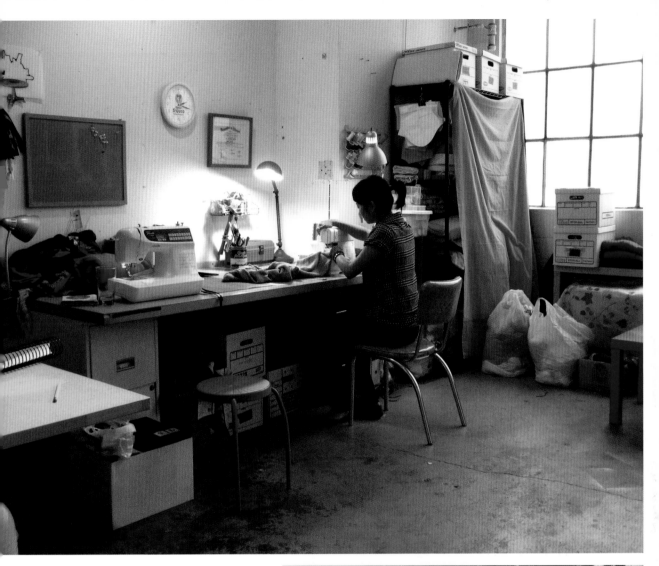

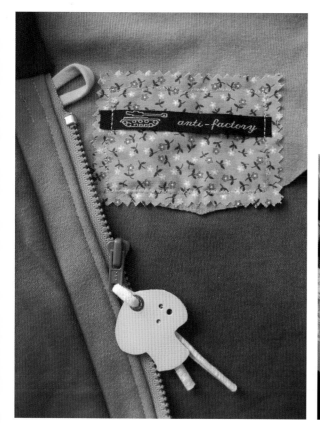

Sarah RaRa

BIRDS OF PREY LOS ANGELES, CALIFORNIA WWW.GLACIERSOFNICE.COM

I think that the role of "maker" is very diffused and inclusive, that art-making is not only specific to drawing, painting, sewing, sculpting, etc. More people are artists or are artistic than are aware of the fact; everyone is making in some capacity.

Making is something inherent to our species, it defines us as a group and as individuals—so it is difficult for me to pinpoint a beginning or an origin of my current practice. I began focusing on art in the traditional sense when I was nineteen years old. That is when I realized I could draw and that I loved to draw and would use it to do something exciting.

I run a small jewelry business called Birds of Prey and a press called Glaciers of Nice out of a tiny freestanding house in Los Angeles. My work area stands nestled between a tangle of tomatillos, hot peppers, and squash on the back porch. Birds of Prey is an ongoing series of wooden pins with hand-drawn birds. Observing the evolving patterns and permutations of these drawings has been like a great imaginary experiment in fantastic ornithology as well as a challenge to produce something beautiful that can be worn by men, women, and children. No gender or age constraints! Everyone included!

Everyone get together! A customer once sent me a photograph of her entire family wearing different Birds of Prey pins, everyone from grandma and grandpa to the little ones, three or four generations. Responses like this are what make my heart soar and are a major reason why I continue making these simple little objects.

When I make crafts, they are really light hearted. I think crafts should be positive and they should make people laugh. They should be about joy and feeling good. I only channel positive vibes into crafts. I think crafts shouldn't be angst-filled. They should be joyful and light.

Interviewed while vending at Art vs. Craft in Milwaukee, Wisconsin.

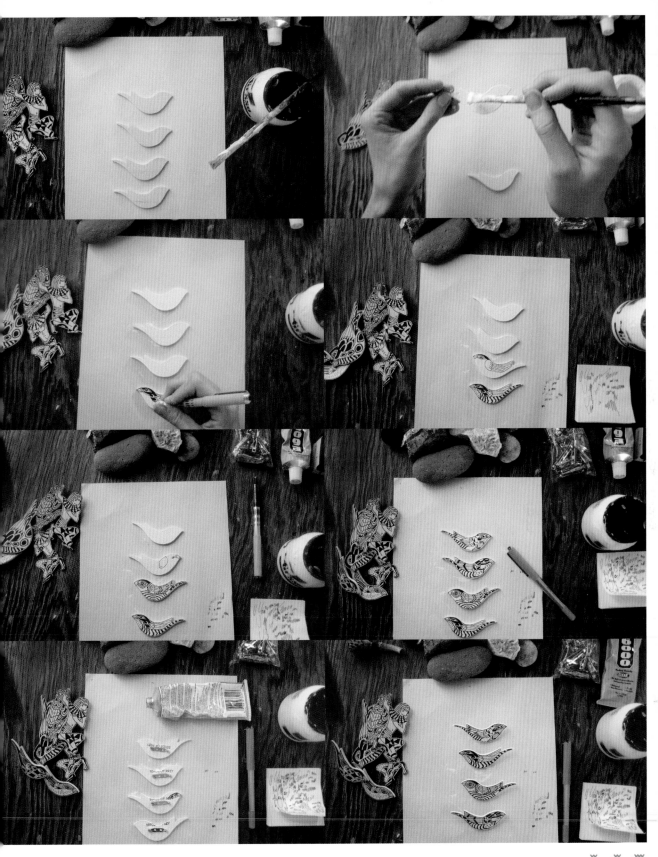

Contributors Biographies

ANDREW WAGNER is the editor-in-chief of *American Craft* magazine. Prior to this, he was the executive editor and founding managing editor of *Dwell* magazine. In 1997, Wagner founded *Limn* magazine, where he was editor-in-chief until 2000. Wagner was also the founding editor of *Dodge City Journal*. In addition to his work at *American Craft*, Wagner is a consulting editor at *Places* magazine and has been a guest lecturer at University of California, Berkeley, Columbia University, Southern California Institute of Architecture, Archeworks, and California College of the Arts. His writing has been published in, among others, *Azure*, *Blueprint*, *Breathe*, *Loud Paper*, *San Francisco Chronicle*, and *Travel and Leisure*.

GARTH JOHNSON is an artist, educator, and writer living in Huntington Beach, California. After a childhood spent with macramé, wire art, Shrinky Dinks, and stained glass, he pursued an education in the field of ceramics, earning his BFA from the University of Nebraska–Lincoln and an MFA from Alfred University. Garth founded Extremecraft.com as a way to chronicle the growing indie craft movement. He teaches at Golden West College in Huntington Beach.

CALLIE JANOFF is cofounder and New York City minister of the Church of Craft. One of her favorite clerical duties is performing wedding ceremonies for all kinds of couples. Her mom was a teacher, parent, photographer, writer, and spiritual explorer whose craftiness influenced her more than any degree program or work experience has. Just the same, she earned her BA in art at the University of California, Santa Cruz, and her MFA in time arts from the School of the Art

Institute of Chicago. She designs and sews leather and canvas bags in her Brooklyn studio and sells them at Callieco.com. She also designs for and teaches crochet.

BETSY GREER is a nonfiction writer, amateur photographer, and dilettante crafter, among other things. She received her MA in sociology at Goldsmiths College in London in 2004. After getting her degree, she decided to write more about crafts and activism, which sometimes combine to become craftivism. Her work can be found on her website, Craftivism.com.

SUSAN BEAL is a craft designer, writer, and editor in Portland, Oregon. She is the author of *Bead Simple: Essential Techniques for Making Jewelry Just the Way You Want It* and the coauthor of *Super Crafty: Over 75 Amazing How-to Projects*. She writes for *Craft, CraftStylish, Bust, ReadyMade, Venus,* Whipup.net, Supernaturale.com, and Burdastyle.com. She also writes a daily blog at Westcoastcrafty.com and a monthly craft column for Getcrafty.com. She sells her handmade work as well as kits to make jewelry and skirts on her website, Susanstars.com.

KATE BINGAMAN-BURT is an assistant professor of graphic design at Mississippi State University. She is also the founding partner of the Public Design Center. Kate's work has been featured in the *New York Times* and in multiple magazines including *Good, Print, Adorn, Dwell,* and *How.* Her work has been published in books like *Hand Job: A Catalog of Type, The Artist's Guide to Making Money, The Crafter Culture Handbook,* and *Becoming a Digital Designer.* Her website, Obsessiveconsumption.com, has been a Yahoo! Pick of the Day and has been featured on numerous blogs.

Image Credits